The Pleasures of Royal Gardening in Sanssouci Park

T0338944

STIFTUNG
PREUSSISCHE SCHLÖSSER UND GÄRTEN
BERLIN-BRANDENBURG

The Pleasures of Royal Gardening in Sanssouci Park

Design, Cultivation, Enjoyment

Published by the General Direction of the
Stiftung Preußische Schlösser und Gärten
Berlin-Brandenburg (SPSG)

DEUTSCHER KUNSTVERLAG

Foreword

Garden history is cultural history. Whether medieval cloister gardens, majestic Renaissance grounds, such as the famous Hortus Palatinus in Heidelberg, or opulent and ingenious gardens from the Baroque period, such as at the French Château deVaux-le-Vicomte – they all reflect the culture of their creators and the time of their origin and development. Sanssouci Park, a UNESCO World Heritage Site, follows in this tradition. Its founder, the Prussian king Frederick the Great, molded his park in a congenial way. He understood just how to meld the beautiful with the practical when creating a classical Baroque garden that literally bore fruit. The king's delight in staging Baroque design was expressed as emphatically as his legendary appetite for fresh and exotic fruit.

Frederick's successors fostered this tradition, each bringing their own particular identity to Sanssouci Park. The magnificent garden complex thus saw expansions and alterations up until the early 20th century, with the Baroque garden developing under the primary influence of the brilliant garden designer Peter Joseph Lenné into a landscape garden of unique accents and design elements. This process shows that Sanssouci Park is not a static museum-like garden, but a living, constantly changing work of art, which is never really finished and offers ever new facets of itself. Exploring these traces is not only fun, but also a way to dip into the cultural history of Prussia and to make new, exciting discoveries. This book will guide you in this quest. Knowledgeable authors and garden experts address quite different aspects of Sanssouci Park to reveal just how truly diverse

it is. Garden art and passionate gardening, splendid scenery, glorious roses, Italian vegetables, and southern fruit are all discussed, as are the entirely new challenges in the face of climate change that affect the care and maintenance of this unique and aesthetic garden ensemble.

I invite you to explore and discover interesting, and perhaps even new paths on your wanderings through Sanssouci Park!

Hartmut Dorgerloh
General Director, Stiftung Preußische Schlösser und
Gärten Berlin-Brandenburg (SPSG)

Introduction

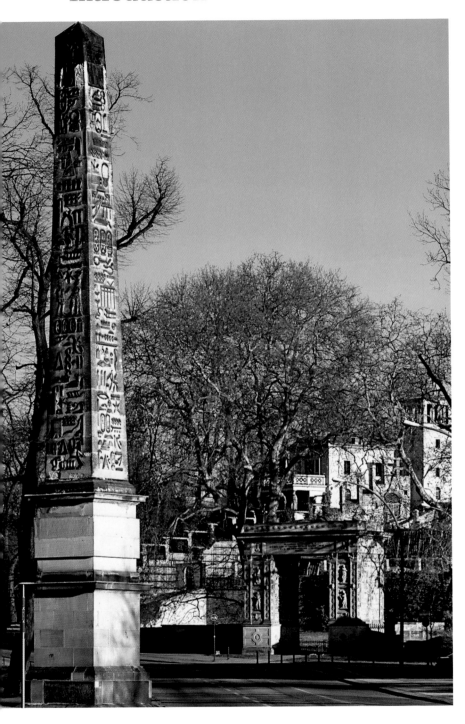

Obelisk (1748) with the Triumphal Gate (1850–51) and Vintner's House (1849)

Sanssouci Park from a Mythological View: Or – Borneo[*] at the End of Hauptallee

Marcus Köhler

Every garden is a reflection of its owner. This is also true for kings. However, as opposed to civilians, they were politicians and state leaders who planted and built edifices. Diplomats, the court, scholars and relatives strolled through their gardens, which were pleasing on their own, but were equally intended to demonstrate the spirit and the power of the monarch. Thus, gardens were always places of representation.

After the First Silesian War, when Frederick II (1712–1786) began to design his "Sanssouci," in 1744, he had a country villa in mind, such as the ones the ancient Romans retired to for a well-deserved life of leisure, following the effort of their political and military careers. Figs and orange trees, as well as innumerable ancient marble busts: all of these props served the king to fabricate a southern ambiance.

And there was more: He embellished his gardens with small buildings and sculptures, which at first seems like impromptu decoration; garden ornaments for ornamentation's sake. If we take a closer look, however, then contexts and stories arise. In this case, it is important to know that Frederick, who possessed extensive general knowledge and had various interests, tried his hand not only as a historian, but also as an opera impresario, writing and composing his own music. Frederick knew how to think in scenes and plots. And as we will see, this also came to his aid in the gardens at Sanssouci.

The shorter south-north axis, which leads from the sphinxes up the vineyard to Sanssouci Palace and from there to the Ruinenberg (Mount of Ruins), may be decoded against the background of his per-

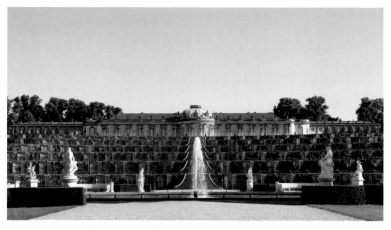

Sanssouci Palace (1746–47), Parterre with the French Rondel and Great
Fountain

sonal philosophy of life as a path of knowledge, which cannot be elab-
orated on here. Not only did the king prove his strong historical vein
in his writings – which distinguishes the philosopher of Sanssouci –
but also through the appropriation of allegorical subject matter, by
transferring the historical facts, myths and literature of antiquity
onto his exploits and way of thinking, thereby bestowing meaning-
ful connections upon his own deeds. The sources to which he referred
were known to his educated contemporaries: stories of the gods of
Mount Olympus, Ovid's *Metamorphoses*, and the writings of the great
Roman thinkers.

Although the king introduced his audience to his empire
through printed descriptions and even an extensive map once the
garden was completed, there are no contemporary statements on the
importance of individual elements. The Rococo period was much
more stimulated by a game that made use of the hint, the allusion,
the joy in decoding and intellectual entertainment. A garden visit
often lasted hours and was gladly repeated and deepened.

How, then, did Frederick present himself? An obelisk decorated
with fanciful hieroglyphics forms the prelude at the eastern entrance
to the park. It stands for Egypt, the first great empire of human his-
tory. Obelisks, once brought by caesars to Rome, found new appre-
ciation in the 17th century. Athanasius Kircher, a famous Jesuit of
that time, even believed he had decoded their strange symbols and
saw them as references to Christian salvation. To avoid giving any

credence to this popular form of interpretation, Frederick, who was an atheist, decided in favor of symbolic hieroglyphics. However, for him a different aspect actually played a more important role: One of his researchers at the Berlin academy, Leonhard Euler, noticed that obelisks also served as sundials. They refer to the course of a day and the seasons, but also to the course of history in a metaphorical sense. Could Sanssouci be seen as a didactic, historical teaching aid?

The gate beyond the obelisk aligned to the main axis is low, inviting us to enter the garden that could be seen behind it, were it not for the majestic Corinthian columns that were meant to indicate that a person of the highest rank lived behind them. However, even without this gesture, it was impressive for an observer on the street to be able to see ancient sculptures lined up to the left and right of the gate. They were part of one of the greatest collections of antiquities in Europe and signaled to those who entered that the ancient world was alive and well at Sanssouci.

Continuing along the main axis we enter – then, as today – a hedge rondel displaying a peculiar contrast, namely busts of Romans and Moors. Since antiquity, dark-skinned people had been viewed as exotic savages *par excellence*. Nevertheless, they are not savages here, but civilized beings clothed in ancient garments. Contemporaries, who visited the gardens in the 18th century, were acquainted with princely "court Moors" paraded before their eyes to show everyone that it was possible to make educated people out of natives by virtue of fine culture. Accordingly, it was not without reason that a Moor also appears in the background of a portrait of Frederick and his sister Wilhelmine as children, as a reference to their education.

Another hedge rondel opens up a few meters further, this time with busts of rulers from Brandenburg and the (Dutch) House of Orange. In principle, it is an assembly of members of Frederick's family, who lived in the 17th century and established a successful alliance, one which encompassed a dominion with immense wealth spanning from London to Königsberg. The English king and Brandenburg elector (Prussian king as of 1701), the Dutch governor, and the Hanoverian elector formed an alliance that held together firmly even during the crises that shook the 18th century. The building styles of the Dutch Quarter, the Stern Hunting Lodge and the service buildings at the Marble Palace in Potsdam still attest to the importance of this connection.

In the next scene, the viewer stands in the parterre, which is to say in the flower garden directly below Sanssouci Palace. The centerpiece of the garden grounds is formed by a fountain basin, at whose center once stood a figure of the goddess *Thetis*. Around her, we see *The Four Elements*, as well as the gods *Mercury, Venus, Apollo, Diana, Juno, Jupiter, Mars* and *Minerva*, who are still assembled here. Representations of the abducted *Deianira* and *Europa*, as well as *Andromache* and *Euridice*, who were just set free, stood between them. Contemporaries knew the story of Thetis, who used every possible trick available to her to escape the husband the gods had chosen for her. A prophecy foretold that her son would one day surpass his father, if not murder him. Neptune, the god of the sea, ultimately tired of her antics and carried Thetis off from her grotto, in order to bring her together with Peleus, her chosen, mortal husband. Frederick II had this scene depicted in two grottos: The Neptune Grotto is still located to the east of Sanssouci; but only the artificial rock gate has survived from the former Thetis Grotto situated to the west.

All the Olympic gods attended Thetis' wedding, which would later lead to the birth of the hero Achilles. Eris, the goddess of discord, was not invited, but came nevertheless. She chose the young Paris to present a prize to the most beautiful goddess at the wedding, a golden apple that she had brought with her for this purpose. Minerva, Juno and Venus immediately began to bribe the young man: the first goddess offered him wisdom, the second power and the third beauty, i.e. the love of the most beautiful woman in the world. The juror chose the last of the three. However, Helen, the coveted woman, was the wife of King Menelaus; Paris had no other option than to abduct her, thus igniting the Trojan War, the most important mythological clash of antiquity.

Frederick's contemporaries were versed in measuring such references against reality. The contrast could not have escaped them that harmony was represented in the Oranierrondell (Rondel of the House of Orange), but here it was in discord. Nor would they have missed the fact that it was left up to a free individual like Paris (or a prince) to choose from several courses of action. Frederick, who liked to make use of double entendres and reflections in his literary and theatrical works, had the subject of the ruler at a moral crossroads appear once again in the Deer Garden (which follows the parterre on the main axis), where he had a copy of the Dresden Corradini Vase

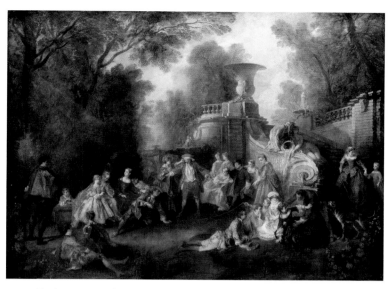

Nicolas Lancret, *Blind Man's Bluff*, before 1737

installed. The vase depicts a scene of *The Family of Darius before Alexander*. According to an old custom it was up to the victorious commander to either enslave or to rape the women of those he defeated; Alexander the Great, however, received them with their dignity intact in a show of respect to his enemy and to the women. In contrast to Paris and analogously to Frederick, he decided in favor of fame and glory and against love and desire.

A new chapter of the story opens in the ensuing *boscage*, a forest-like area that in the garden designs of the Italian Renaissance was shaped as an archetype for untamed feelings or the subconscious. It is also a place where freedom develops, leaving its mark on cultural history through plays such as Shakespeare's *A Midsummer Night's Dream*.

It is no coincidence that a French theater troupe known as the "enfants de sanssouci," who were driven out of Paris, had retired to the woodland hunting gardens of the kings at the beginning of the 18th century. There, between the statues and the small temples, they performed plays that were rural, cheerful and liberal. These works formed the basis for scenes that would later be captured by the painters Lancret, Pater and Watteau, whom Frederick collected.

Sanssouci's naturally designed boscage, the Deer Garden, is indebted to this piece of theater history. Scenes of dangerous, uninhibited, unrequited and deceitful love already appeared in the first rondel:

Friedrich Christian Glume, Rondel of Muses, c. 1752

Mars Bound by Cupid, *Venus Enchained by Cupid*, *Diana and Actaeon*, *Mercury and Alcmene*, fauns and bacchantes, etc. It is followed by the Rondel of Muses and further figural groups depicting abductions of women: *Pluto and Proserpina*, *Bacchus and Ariadne*, *Romans and Sabine Women*, as well as *Paris and Helen* for the second time. Compulsive desire and the consequences of rash, mundane love are the subjects here. It is no coincidence that the figure of Venus is repeated six times and that there were seven statues of the fiery god Vulcan in the boscage.

Before the victorious end of the Seven Years' War led to the expansion of the Deer Garden to the west, the Marble Colonnade was once a formal highlight in the park. Although it belonged to the rondels described above, it was torn down in 1787. Love in all its awkward forms was transferred to the sphere of Ovid's *Metamorphoses*: *Narcissus*, who fell in love with his own image and was transformed into the flower of the same name; the tragic figure of *Adonis*, also immortalized as a flower; or the chaste *Syrinx*, first turned into reeds and ultimately into pan pipes. However, here it is not death, but transformation that immortalizes these unacceptable loves.

It was in this vein that the garden was originally formed and completed. It became a perfect counterpart to the royal grave planned for the uppermost terrace, which was also meant to represent the human passage into nature.

However, things did not turn out as planned: In 1763, Frederick won the Seven Years' War and began immediately to expand the park

grounds to the west. In 1768, he had a temple-like, closed rotunda specially built for his substantial collection of antiquities. If we look closer at the mass of sculptures that once stood in the park, individual themes emerge. The Romans were an initial focus, and were displayed through a great number of portrait busts. Under Frederick, one of the most important groups of antiquities of the 18th century came into being. It depicts the scene where Ulysses exposes Achilles, the son of Thetis, who had dressed in women's clothes to hide among the daughters of Lycomedes, whereupon Achilles draws his weapon and goes off to the Trojan War. The peripheral figures – a *Faun*, *Venus* and a representation of the *Rape of Proserpina* – once again bring to mind the theme of desire. There was a relief over the entrance of the temple that depicted Vulcan forging his weapons. Furthermore, the noble Alexander and the philosopher emperor Trajan reemerged, under whose reigns giant empires flourished. Their deeds stand in blatant contrast to the Roman empress Messalina (of whom there was also a bust), who gave her name to misalliances, and came into world history as a whore. Lust and egoistic desire are attributed to her; embodied by a woman.

In the Temple of Antiquity just one figure stood out from the series: a modern bust of *Cardinal Richelieu* by François Girardon, which was the key to understanding the ensemble. Armand-Jean du Plessis, cardinal and minister of state under Louis XIII of France, was the absolute personification of anti-Habsburg politics. In the Seven Years' War Frederick also fought against the Habsburgs, namely against Maria Theresa, a woman, who only came to the imperial throne through an overreaching compromise known as the Pragmatic Sanction, which she would use exclusively for her power politics. By her side was the fickle Empress Elisabeth of Russia, the king's second enemy, whom Frederick once disparagingly referred to as "Messalina." With the addition of the Temple of Antiquity and its aesthetic program, the interpretation of the parterre, which had previously been a general representation of the consequences of false decisions, also changed. From this point on at the latest, it is clear that the Trojan War, which began with the *Thetis* fountain in the parterre, could now be understood as an allegory of the Seven Years' War: here were the fame and the glory of the rulers Alexander, Trajan and Frederick, and over there the beauty, temptation, and weak spirit (exemplified in Paris, Maria Theresa and Elisabeth).

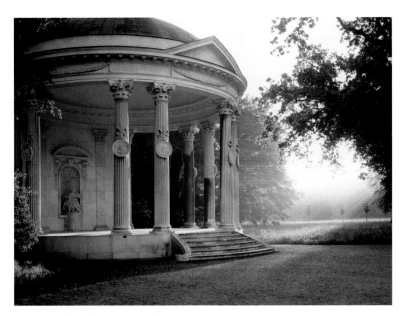

Temple of Friendship (1768–70)

This black-and-white categorization, far too easily divided into the sexes, also caused Frederick to consider whether princesses were free to respond differently than "in accordance with their nature" (i.e. emotionally or instinctively). He ultimately found his paradigm in his immediate environment; namely in his sister Wilhelmine, Margravine of Brandenburg-Bayreuth. The sole mosaic in the Temple of Antiquity, which stood out by nature of its material, originated from her estate. It depicts an unimportant bathing scene, which, nevertheless – as Matthias Österreich (one of Frederick's experts) wrote in a guide – was found in an imperial villa in Palestrina that like Sanssouci had been designed as an ensemble of terraces. With some detours, it changed hands from Pope Urban VIII to Wilhelmine and ultimately came to Sanssouci.

It is therefore no coincidence that the architectural pendant to the Temple of Antiquity is a monument to the Margravine of Brandenburg-Bayreuth, who died in 1758. It was erected exactly 10 years after her death. Frederick wrote that, although his ideas were based on the temple structure that Cicero had planned for the garden of his villa to honor his deceased daughter Tullia, he gave instructions to Räntz, a sculptor from Bayreuth, to represent Wilhelmine true to life after a portrait by Antoine Pesne, as a seated pilgrim with a copy of Voltaire's

book *Traité de l'amitié*. The scenic medallions, which are attached to the columns of the open temple, designed as a rotunda, show classical pairs of friends. The key for this initially unusual juxtaposition is offered by a monument, which Frederick had installed at the Herrngarten in Darmstadt to honor the late Landgravine Caroline of Hesse-Darmstadt, that bears the Latin inscription *Femina sexu – igenio vir* ("the gender of a woman, the spirit of a man"). The fact that a woman could be male in spirit became the subject of the Temple of Friendship at Sanssouci, making the mistakes of the empresses Maria Theresia and Elisabeth, discussed above, all the more apparent.

Beyond these two buildings, we leave the dark boscage and enter a light, semicircular section of lawn that unfolds in front of the New Palace. In Frederick's era, the stage was populated by athletic fighters as well as *Asclepius* (the god of health and medicine), dancing girls, the gods *Apollo*, *Juno*, *Ceres*, as well as *Cleopatra and Antinous*, representing the two different kinds of love (desire and denial). Moreover, another series of historical figures, important to Frederick, that included *Julius Caesar*, *Cicero* or *Antinous*, was located on the south side of the king's private suite. From this semicircle, the view opens up onto the New Palace, which was begun in 1763 at the end of the Seven Years' War. It was originally called the Holländisches Palais (Dutch Palace), and completes the circle to the Oranierondell (Rondel of the House of Orange). Was this, perhaps, intended as a celebration of family unity?

Various heroes of the Trojan War arming themselves for battle, among them Achilles,, appear on the façade facing the gardens. Only the story of Perseus and Andromeda is embellished further, showing him as a chivalrous hero, who successfully fights for a woman and kills off evil in the form of Medusa. The horse Pegasus originates from her blood, which as a result appears once again on the courtyard side of the New Palace, where it is admired by Minerva, and the Muses.

Warriors and gods of the Trojan War (including Paris) appear again on the plinth level. Up above on the façade, however, a musical competition among the gods develops further under Apollo's aegis, at the center there is a royal crest flaunting the motto "nec soli cedit" (he yields not even to the sun). High above, on the majestic palace dome, the same three goddesses, who once bitterly quarreled, now hold aloft the Prussian crown in peaceful unity.

The gods have assembled once again, but this time – in contrast to Thetis' wedding – it is to hold a peace banquet, more specif-

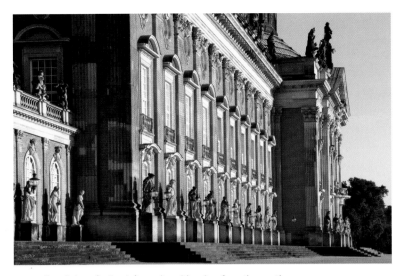

New Palace (1763–69), garden side, view from the south

ically in the ceiling decoration of the marble festival hall. The cup-bearer Ganymede, who has replaced his predecessor Hebe, attests to the beginning of a new and happy era.

This becomes even more apparent to visitors if they approach the New Palace from the garden side. In the first planning phase of the garden (until around 1754), Frederick wanted to set up a grotto at the western end of the Hauptallee. Its foundations had to make way for the construction of the New Palace, but conceptually, it was only relocated and reestablished as the Grotto Hall in the New Palace. From here, as from the Marble Hall one floor above, we enter a protruding vestibule in both cases, which seem like replicas of the entrance hall at Sanssouci Palace, especially their freestanding columns. This was no coincidence. On the contrary: if we look out the middle window in the vestibule at Sanssouci, we see the ruins of "ancient Rome" on a hill in the background framed at the center of the palace courtyard's colonnade. Moreover, from both of the vestibules at the New Palace, which are one above the other, our view falls on a giant triumphal gate set amidst a series of columns. It is a theatrical exclamation point to an ingenious aesthetic program, in which not only victory goddesses and heroes turn up, but also crests and the Prussian emblems of the eagle, crown and scepter, which clearly refer to the victorious finale of the Seven Years' War and the greatness of the king. The entire ensemble is a glorification of this great historical feat. *Fortuna* and *Victory* on

the domes of the two palaces herald these tidings to the world, which is represented by a seemingly endless avenue of linden trees. And with this, the curtain falls on an excellently staged production.

The subsequent kings, Frederick William II (r. 1786–1797) and Frederick William III (1797–1840), spent little time looking after Sanssouci. Perhaps they still remembered far too well the human deficiencies and theatrical exaggerations of the old monarch, or possibly also felt a certain respect. In any case, in the end they left everything just as they had found it.

This first changed under the young crown prince Frederick William (1795–1861), who became acquainted with the "historical" Frederick in his childhood. However, as he was educated during the time that Napoleon had subjugated Prussia, a rising major power, Frederick William's teachers not only provided him with facts, but also with the cliché of an ascetic, glorious, artistic, and all-around exemplary king. The likelihood that Frederick had created this image himself was disregarded, and accepted far too gladly in this difficult period.

The crown prince saw it as his duty to preserve the works of his great ancestor, to further embellish them, and – later as king – to leave behind symbols of his own glorious reign. It seems pointless to speculate whether he really understood the intentions of his ancestor or whether the putative fame of Frederick the Great, who had written himself into the history books and the consciousness of his people, made the aforementioned self-representations superfluous. Nevertheless, during the course of the 19th century, the mythological narrative framework of the 18th century was set aside. The publicist Belani, who may be considered Frederick William I's extended mouthpiece, even wrote: "Without a doubt everything was magnificent and resplendent, but it also evinced a faded glory. The refined taste of modern times did not allow for the recreation of this garden decoration lacking in cultural aesthetics." (Häberlin, 1855, 35). Even if Frederick William IV had many figures installed that are similar to those of his ancestor Frederick (for instance, an abundance of satyrs, fauns, bacchantes and representations of Dionysus), this should not obscure the fact that – according to the most recent research – he destroyed the Frederician form of the *Lycomedes Group* by having the figures restored and transformed into Muses, and then had them transferred to the art collections in Berlin. Antiquity no longer served him as a primary narrative, but rather as a stylistic epoch, which he

held in aesthetic and scientific esteem. Consequently, copies of the Muses now in museums appeared at Sanssouci, where they were installed as quotations: five terracotta statues stand in niches below the windmill; four are located on the edges of the fountain around the central water basin below Sanssouci; merely *Clio*, the Muse of historiography, was given particular significance through the statue's installation on the stair stringer in Charlottenhof.

The way in which they are grouped also shows that Frederick William was interested in other subjects than his great-great uncle. For instance, he positioned various pairs on the terrace of Charlottenhof: two ancient marble sculptures that he supposedly excavated himself in Italy in 1828 (*Gaius Julius Caesar*, *Fortuna*), two bronzes based on antiquities (*Clio*, *Apollino*) and finally two sculptures by Berthel Thorwaldsen (*Mercury*) and Antonio Canova (*Paris*), the most sought after modern "Neoclassicists" of the time. A comparable pairing can also be found in the interior of the Roman Baths, for instance a bronze *Ganymede* (*Boy with a Bowl*, 1838) and a figure of *Hebe* made of *Steinpappe* (a type of papier-mâché), a chaste *Artemis of Ephesus* and a tantalizingly *Venus of Capua* (both plaster casts made based on classical sculptures). The installation practice took on the character of a teaching collection, at whose height – as a type of outdoor museum – the Nordic and Sicilian Gardens (1857–60) with their many sculptures came into being. Models, copies and new creations were displayed, but also the most diverse materials in equal measure. The numerous "substitute materials" with which the figures were frequently produced (zink casting and cast stone, terracotta, galvanoplasty, etc.), were not considered cheap, but rather modern materials. They allowed Frederick William to show off his progressiveness. Even the visual imagery broke fresh ground. On the terracotta Triumphal Arch on the Mühlenberg (1850–51) classically dressed female figures encircle ancient utensils that distinguish them as personifications of telegraphy and the railroad; and at the Large Orangery (1851–64) the personification of industry appears in just such a garment with a cogwheel and pliers.

The combination of art and technology, which seem less compatible from today's point of view, nevertheless corresponded to Frederick William's intentions. His most obvious and presumably most important project concerned the water system at Sanssouci, which in the 18th century consumed high capital investments without ever

having functioned. In 1826, while he was still crown prince, he had a steam engine building (no longer extant) constructed as the first "testing station." Located next to a pond, it was set on the axis to the Charlottenhof estate, which had just been converted into a Neoclassical style for him. From the steam engine building's balcony, one looked out over the pond and the Rose Garden onto the terrace of the new country estate. The chimney was construed as as an oversized candelabra so that it would picturesquely set the stage for its ascending smoke. Since the working pumps were a success, immediately after his ascension to the throne Frederick William began an installation of water displays at Sanssouci, leading to the construction of a further steam engine building, the "Mosque," on the Havel River, from 1841–43. Where once not a working fountain was to be found, more than 50 fountains, water sprays and man-made cascades sprang to life during the course of his reign. All possible mythological sea creatures were conjured up in order to adorn this watery proliferation with visual imagery. However, it was no longer a matter of placing them in multilayered relational juxtapositions, but merely the opportunity to illustrate and compare the glorious deeds of the earlier king with the current one, and yet to outdo Frederick the Great by means of state-of-the-art technology. This was also emphasized by Belani, who published the *Geschichte und Beschreibung der Fontainen von Sanssouci* (History and Description of the Fountains of Sanssouci) two years after the king ascended the throne. He claimed: "Conceived by the genius of Frederick the Great, the piety and the purified taste of our reigning king, His Majesty, has made it possible to realize these plans. What ignorance made impossible back then, the intelligence of our century has achieved with swift assurance ... putting into the hands in the nineteenth century the gratifying proof of our great strides and advancements beyond the eighteenth century."

Frederick William recognized how the new fountains could be used to his own advantage. The bronze figure of a flounder is found at the entrance to the Roman Baths, because Frederick William's family had given him the German nickname "Butt" (flat fish) due to his corpulence as crown prince. On a round bench on the terrace at Charlottenhof, "Butt's" royal household (at least in a few portraits) emerges as sea gods on a fresco weathered by time. They looked across at the porcelain portraits on the portico facing the terrace, where members of his family and courtiers were also to be seen. Aside from the Roman

Baths, where the crown prince paid homage to his parents, his father-in-law, Maximilian II of Bavaria, and the Great Elector and his wife, there are repeated references to the royal family, particularly to the queen, whose bust stands on a column in front of Charlottenhof.

However, these progressive, technology-embracing works of art should not deceive us into thinking that Frederick William was anything but modern; in fact, he was an increasingly reactionary and conservative monarch. The terracotta Triumphal Arch on the Mühlenberg vineyard was dedicated to his brother William (later emperor William I), to commemorate his successful suppression of a revolt in Baden. The revolts of 1848, which also claimed lives in Berlin, also disconcerted the king: His concept of the divine right of kings was not in alignment with the aspirations of the common people. He sensed revolutionary activities. It is no coincidence that programmatic sculptures were erected during the following years, such as a copy of the *Farnese Bull* (in 1858 in front of the Large Orangery), which could be understood as a victory of justice and the punishment of evil. Even *Hercules Taming the Cretan Bull* (below the Picture Gallery since 1850) or the *Eagle, Felling a Deer* (1846–47 in the "Paradiesgärtl," i.e. the "Little Paradise Garden") could be interpreted as depictions of the "survival of the fittest." The numerous fighting and dying amazons were also likely part of this program.

Again, we must be aware of the times: by 1806, the Holy Roman Empire of the German Nation for which Frederick II had fought was gone. The new Austrian Empire continued to exist as one entity, but the other – mostly North and Central German principalities – formed a conglomerate that was shaken by numerous political crises during the process of self-identification and attempts at national unity. The strange contradiction that Prussia declined the German Imperial Crown offered by parliament in 1848 only to accept it after the military victory over France in 1871, shows that the Frederician idea of gaining power by the glory of war determined the monarchy far into the 19th century. And yet, there's more: It has become evident that not only did Frederick William IV try to imitate Frederick II during his lifetime, he also strove to surpass him. In view of the Christian imagery developed by the king in the Marly Garden in the 1840s, which can be read as an antithesis to the atheism of his great-great uncle, even the function of his ancestor as a role model needs to be questioned. Old Fritz probably served the young king more as a mir-

ror in order to present his own alleged political greatness. In the end this plan petered out into isolated parts.

For contemporaries of the 18th and 19th centuries, classical mythology and the literature of antiquity belonged to the educational canon. Nonetheless, they regarded the stories in different ways. Frederick clearly saw great human and historic archetypes in them, with whose help he could align his own actions in timeless contexts. Frederick William, who grew up in the age of critical science, lacked this overall view. He experimented, fantasized, personalized, researched, and established a reference somewhere only to lose himself again. Myths are treasure troves to be used at one's own discretion. Known as the romantic on the throne, he dreamt of a new, other, and better world. Accordingly, in a fairytale novella that he wrote (c. 1818) for his sister Charlotte, he no longer troubled himself with myths originating from Italy or Greece. Instead, he traveled to the other side of the world, to Borneo.

* The Frederician sections of the commentary presented here are based on my accounts in a work jointly published with Adrian von Buttlar, *Tod, Glück und Ruhm in Sanssouci – Ein Führer durch die Gartenwelt Friedrichs des Großen* (Ostfildern, 2012).

Marly Garden (1846–47) with Albert Wolff's *Flora*, 1850

Sanssouci – A Walk through the History of the Gardens

Hans von Trotha

Gardens are living works of art teetering between nature and art. They change – over the course of a day, with the seasons and naturally, over the years, the decades or even centuries. The vegetation changes, as do the surroundings, buildings take on a patina, fall to ruin or are restored. Many gardens experience different levels of care, reductions or expansions, as well as losses and modifications of every kind. Occasionally they disappear and are reconstructed again. Historical gardens are always contemporary gardens, in which historical forms, elements, and ideas are preserved. If we regard gardens as historical grounds, we must always be conscious of the fact that we are projecting ideas onto actual existing places. If we do this, the grounds begin to talk to us, regardless of whether the architectural details, plant arrangements and decorative elements are old, reconstructed or imitated. They convey different fashions in garden design and that these were more than just mere fads; in fact, that they represent positions in aesthetic, philosophical and political debates that should be taken seriously.

Whoever strolls through Sanssouci today, experiences a synthesis of the arts that has evolved over centuries, in which styles with quite different uses of forms and messages meet or even overlap in an ensemble of palaces and garden spaces, statues and park buildings, fountain displays and gardening styles, which originate from different epochs and contexts. Today, Sanssouci Park is neither purely Baroque or Rococo, nor is it a park of the Enlightenment or of Romanticism. It is a garden of our times, in which landscape gardening of

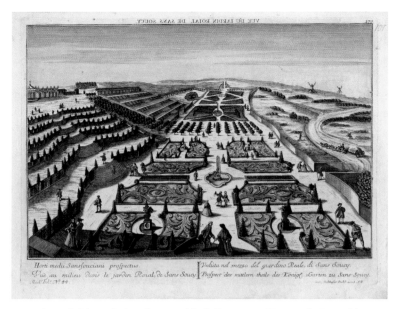

Georg Balthasar Probst, *Sanssouci Park, Terraces and Parterre in Front of the Palace*, c. 1750

previous epochs can be experienced in a powerful and poetic way. The palaces and buildings can largely be experienced in an adapted landscape environment. This is important, because the spirit underlying Sanssouci's architecture also characterizes its surrounding gardens. Thus, to stroll through Sanssouci is to walk through its garden history.

The latter experienced a radical break over the course of the 18th century. Although gardens had been organized in straight lines and designed with geometric forms for centuries, by the end of the 18th century at the latest (in England already as of 1730) the planting, aesthetics and arrangement of paths no longer imitated mathematics – the basis of all geometrical design – but rather nature itself. This was based on a change in philosophical attitude. Rationalism in the 17th and early 18th century assumed that the world only becomes what it is through reason. The guiding science of this school of thought was mathematics, which is reflected in the geometrical forms to which the plants in the gardens of the Renaissance, the Baroque and also the Rococo periods were also subjugated. This should not to be understood as an act of conquest. Instead, the ideas of that time purported that by pruning trees and bushes the gardener brings to light the aes-

thetic potential inherent in nature. Only at a later stage would the resulting design also become an emblem of political absolutism, represented in particular by Versailles, the vast Baroque garden of the French king, Louis XIV, which ultimately would serve as the formative pattern for most gardens of the European Baroque. However, it is important to realize that mathematical structure initially influenced the style of garden design, not the power of political will.

Similar views apply to the English landscape park or English garden, so typical of the Age of Enlightenment, which was and continues to be associated with the ideology of political freedom. These gardens completely renounce geometrical forms and straight lines. William Kent, the first advocate of this approach, coined the phrase: "Nature abhors a straight line." Thinkers of the Enlightenment did not believe that nature's potential lay in abstract laws; instead they paid homage to the shapes provided by nature in their concepts of beauty. This break in garden design was preceded by a rupture in the history of philosophy. Rationalism (whose intellectual center was France) was replaced by sensualism (originating in England), a philosophical doctrine according to which the world has not become what it is through the reason, but through sensory impressions. Where rationalists use an abstract, objective rule as their yardstick, sensualists only put their faith in tangible and subjectively experienceable effects. Rationalist philosophers (and the gardeners aligned with them) beautifully arrange nature according to the rules of reason. Sensualist philosophers find nature beautiful as it is, attempting to establish reasons why this is so (which proves to be less simple). Depending on the desired effect, the landscape gardener mimics nature in its beauty in individual scenes and on a smaller scale. Hence, in the respective sections of the garden, I, the viewer, am confronted with a scene; a very personal experience of nature, which , has been arranged by a cunning director in such a way that the effect is not as indebted to chance as it seems. It is just as carefully calculated as the general clarity and evident formal severity of a Baroque parterre. Gardens are always art; never purely natural, even if they present themselves as such.

Once this fundamental difference becomes apparent, the different sections of Sanssouci Park can be quickly classified. Here, paths wind circuitously through romanticized landscapes; there, overview, predictability and symmetry prevail. Here, the Enlightenment has

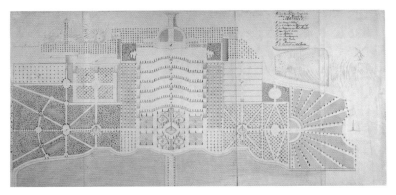

Potsdam, Sanssouci Park, site plan, c. 1750 (unknown artist)

left its mark, succeeded by Romanticism; there, gardeners followed the principles of the Baroque and subsequent Rococo period, which opened the strict rules of garden design borrowed from architecture – for forms, motifs and moods towards nature – without renouncing the principals of geometry.

Unlike other residential palaces and gardens, from the beginning Sanssouci was conceived as a place of retreat not representational function. In spite of its luxurious splendor, the effect of Sanssouci as a whole is of a more private nature. This resulted in a softening of certain principles. As a rule, the Baroque park is organized on a central axis, which might have several parallel side axes and be intersected by one or several traverse axes. A general view was granted from the central rooms of the palace and from the terrace. Sanssouci also has a central axis, which the viewer cannot see from the palace, however. It is neither part of a symmetrical whole nor an organizing axis, but developed as a thoroughfare resulting from expansions. The patron's interest was focused on the ensemble: the palace atop the vineyard terraces. This vista in the spirit of the Rococo engages the design principles of the Renaissance, which formed the nucleus of European garden design and preceded the Baroque period.

Following the revival style of ancient villas made popular during the Italian Renaissance, garden installations became a natural component of representative architecture, and especially of a country house lifestyle. In the garden design of a country estate, the Renaissance, the Baroque, the Rococo, the Enlightenment and even Romanticism influenced more than just decorative embellishments; in fact, they were fundamental for the organization of the entire grounds.

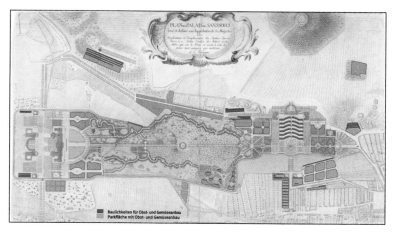

Johann Friedrich Schleuen based on Friedrich Zacharias Saltzmann, *Sanssouci Park*, 1772, colored etching, digitally edited by Beate Laus with the kitchen garden areas marked in color

A villa is the country house of a town dweller, which does not rely on agricultural areas, and is a place of leisure for relaxing, philosophizing, fostering the arts and conversation. Garden grounds comply with these purposes. Moreover, thinking about the art of nature expanded during the Renaissance. The garden is a place where art and nature directly meet and overlap. Therefore, in historical terms, gardens have always changed when the relationship between people and nature changed. Medieval gardens cut themselves off from the outside world with high walls. Renaissance builders opened their villas to nature by adding gardens, loggias, belvederes and terraces. French Baroque parks arranged nature according to theoretical conventions. Ultimately, the landscape gardens of the Enlightenment and of Romanticism expressed a new understanding of nature; a modern relationship of human beings to the world that surrounds them.

For all its Rococo splendor, Sanssouci Palace follows the model and bearing of a Renaissance villa. The suite of terraces perpetuates the concepts of the Renaissance garden under the conditions of the Rococo, which is modern and also not, if we consider that in England landscape gardening was already fully developed by that time. However, it would be some time before it also took root on the continent.

Sanssouci Palace and its terraces, as well as the rondel with the fountain preceding them, are the heart of the Rococo grounds. The

View of the Rock Gate (1843) from the Rondel of Muses (1752)

ensemble is intersected by a long straight line, which today we perceive as the main axis of the garden. At one end we intuit the New Palace, a very late Baroque building, surrounded by an equally late Baroque garden. The effect of these straight lines and the geometric principles they are essentially linked to, coexist in rich contrast to the garden spaces, which are structured quite differently.

When entering the park through the "Grünes Gitter" (Green Gate), we initially follow an avenue or main thoroughfare, a central and defining element of Baroque garden and landscape design. Our gaze is drawn to the center of the grounds, to the terraces and the fountain. The avenue is flanked by canals, also a main element of Baroque garden architecture. On entering the park from the avenue, we can either chose to follow the Baroque park straight ahead,

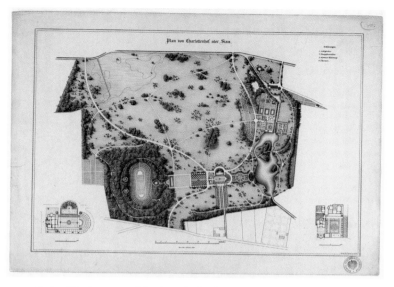

Gerhard Koeber, map of *Charlottenhof or Siam*, c. 1839

or to enter a landscaped garden on the left or right, which is characterized by paths that tend to disappear around a bend – a successful prelude, which is almost a brief introduction to a historical retrospective. However, if we proceed in a straight line (which most visitors do intuitively), we soon reach the fountain and are completely enclosed by a charmingly designed (Rococo), but formally stringent (Baroque) world, with no notion of the calculated wilderness of the landscape gardens concealed by hedges.

And yet, we have not crossed a canal but a winding, artificial river; the typical lifeline of a landscape garden. Crossing the bridge signifies stepping into the Baroque and Rococo periods. The sound of one of Jean-Baptiste Lully's dances or a flute concert by King Frederick should start up at this moment, because the Baroque garden sees itself as a synthesis of the arts, which addresses all the senses and integrates all of the arts.

If we explore the park to the west, we can chose to walk along the straight axis in the spirit of the Baroque and Rococo towards the New Palace, or to follow the accompanying paths, winding to the right and left in the style of the Enlightenment and/or Romanticism. This example elucidates an important characteristic of each of the two garden designs: A Baroque viewing axis usually follows a direct path, which can be used as it will guide you, while a landscape gar-

den follows the rule that one never reaches what one sees directly, and that one also never knows where a path will lead to next.

By choosing the winding path to the left, we reach the Chinese House. Having arrived, there is no viewing axis to any other buildings or to topiary plants. Instead, we seem to find ourselves in an enclosed natural space, even if completely artificial in design. We are surrounded by all kinds of wooded areas in changing colors. Where there are vistas, they are views of "nature," of planted landscapes.

Like a shifting landscape painting, this artificial nature also gives way as the path winds past the Roman Baths towards Charlottenhof Palace, which in its design and appearance is altogether no longer a palace, but an Italian villa, set in an ideal landscape – except that the dimensions and proportions of the landscape have been adapted to suit the architecture, and not the reverse. Charlottenhof embodies ideal landscaped gardens typical of Romanticism, which is to say of the early 19th century.

Where the first landscape gardens of the Enlightenment had completely renounced geometric forms and visible traces of human intervention, above all emphasizing winding paths, and imitating nature enriched with meaningful architectural quotations (traces of which can still be intuited on Peacock Island or in the New Garden, for example), the gardeners of the Romantic era developed a so-called "mixed style." This design, applied in a tightly defined area around a palace frequently camouflaged as a villa, included formal grounds with flower beds, fountain displays and geometrical beds in order to design an ever newly unfolding series of shifting landscape paintings in the extended park.

Claude Lorrain was one of the favorite landscape painters of the era. A series of engravings of his landscapes is displayed inside the villa. They are role models for this manner of landscape gardening; clearly serving as the inspiration for these grounds. Apart from their practical functions (living quarters at the palace, guesthouse and gardener's apartment at the Roman Baths), the buildings also have poetic significance. They enrich the artificial landscape with meaning and locate it on a sentimental map.

Charlottenhof Palace is the expression of a deeply rooted affinity towards Italy, which its patron, Frederick William IV, shared with his generation. Here, quite diverse formal elements of the Rococo grounds and landscaped gardens of Sanssouci are juxtaposed, equally

outstanding examples of garden design in their respective epochs. In different ways – both surprising and overwhelming – they convince us of the deeply felt, poetic fiction that we are in Italy.

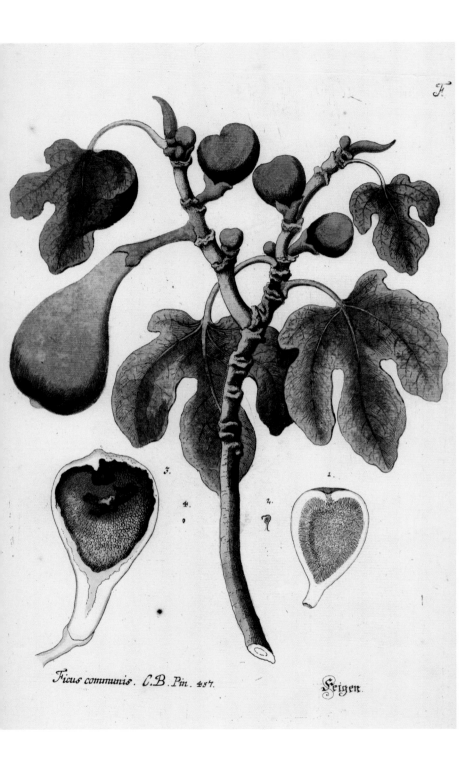

Ficus communis. C.B. Pin. 457. Feigen.

Common Fig, Georg Wilhelm Knorr, *Das Reich der Blumen*, 1750

Beauty and Utility

Marina Heilmeyer

The history of Sanssouci Park begins almost 300 years ago, in 1715, with a kitchen garden commissioned by Frederick William I. In this garden, planted outside the gates of Potsdam, fruit and vegetables were grown for the royal table. It also had a bowling alley and shooting range for entertainment. In addition to games, a salad hand-picked and prepared by oneself was one of the Sunday summer rites enjoyed by the Soldier King.

Frederick William I named this kitchen garden "My Marly" in reference to the much larger gardens of *Marly-le-Roi* where Louis XIV cultivated exotic fruit and vegetables. The Sun King's passion for gardening strongly influenced the cultivation of fruit in particular, making it fashionable for European rulers to devote themselves to growing fruit trees.

Since he was a child, Frederick II had been interested in gardens, particularly in fruit growing; French garden literature and examples found in many classical texts that survived influenced him equally. As a lover of cherries, Frederick would have enjoyed the tale of Lucullus, the Roman commander who brought the first sweet cherries from Asia to Europe and had them carried through Rome in a triumphal procession. In ancient Rome it was unthinkable not to offer precious fruit from one's own garden at the end of a meal.

Accounts of the Emperor Tiberius, who was as passionate as Frederick about cultivating melons, must also have made a strong impression on the crown prince when he was living in Neuruppin with its Amalthea Garden.

Marly Garden, fan-shaped bed with a sculpture of *Flora*

Like his role models from antiquity, he asked Pomona, the Roman goddess of fruit, to bless his fruit trees. According to tradition, she provided humankind with its first kind of sustenance and greatest joy, as, like in the Garden of Eden, the fruit she provides is easy to pick without having to labor and plow. Together with Flora, the goddess of flowers, Pomona would welcome visitors – first in Rheinsberg, later in Sanssouci – and draw their attention to the synergy of beauty and utility present in these gardens.

Figs and Grapes in the Vineyard

It is extremely rare that the first idea for a garden can be pinpointed as precisely as in the case of Sanssouci. On August 25, 1743, Frederick II was dining on a hillside high above his father's kitchen garden. As he recounts in a letter to his mother, he was enthralled by the glorious view of Potsdam and its surrounding landscape threaded by the sparkling ribbon of the Havel River. Furthermore, his knowledge of horticulture meant that he recognized how favorable the slope of the south-facing hillside was for growing fruit and wine. In the very same month, he ordered that vines and fig trees be sent from Marseille, and a year later, in August 1744, shortly before the outbreak of the Second Silesian War, he gave the order to terrace the hillside. In

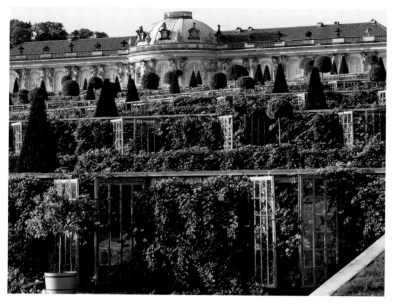

Terraces at Sanssouci with Reseda vines and three different kinds of fig

1745, the terrace walls were furnished with glassed-in alcoves, and Frederick requisitioned another consignment of vines and fig trees. These orders definitely merit detailed attention: Ordering vines for a vineyard is self-evident, but Frederick's craving for fresh figs would have been easily satisfied by the 30 fig trees already growing in his father's kitchen garden. So there must have been another reason.

As is often the case with Sanssouci, there seems to be a deeper symbolism apart from the obvious benefits and enjoyment provided. Frederick may very well have been alluding to deeper Christian and ancient interpretations, to God's benevolence as well as to Bacchus and Dionysus. However, likely as not, the fig trees were paired with the vines in order to invoke a Solomonic prophecy. In the Old Testament, wise King Solomon promised each of his subjects that they would live in peace and prosperity under their very own vine and fig trees for as long as Solomon's felicitous reign lasted. Possibly Frederick II wished to suggest that he had a similar intention.

The term "vineyard," and the lush Reseda vines of today, suggest that the grapes grown here are meant for making wine. However, Frederick's vineyard with its magnificently curved terrace walls and perfectly shaped central staircase was where the most noble of fruit was cultivated for the royal table. During Frederick's rule fig trees

Cherry tree in the 4th Guest Room at Sanssouci Palace

were only grown along the lowest of the six terraces. In the five higher walls, selected grapes were cultivated in 140 glass alcoves, each one bearing a small tin plaque with the provenance and varietal name of the vine it protected carefully inscribed. Cherries, apricots and peaches, Frederick's other favorite fruit, grew between the alcoves, on espaliers spread across the 150 spaces on the wall. Invoices document that in 1746 a Dutch nursery delivered 200 pear and apple trees, which had been artfully shaped into small pyramids. The size of this order would lead one to surmise that these were intended for the terraces of Sanssouci, and that 180 of them would have occupied the wall areas where the taxus (yew) balls are today. In summer, between these topiary spheres on the ledges above the glass alcoves, stood the pride of Sanssouci: stout orange trees with round crowns in green wooden tubs which, like a musical *basso continuo*, echo the rhythm of planting. Should it be true that fruit pyramids rather than yew spheres adorned the walls, then originally the only trees on Sanssouci's terraces would have been those producing delicious fruit that could be

handpicked and enjoyed. Thus the vineyard would have resembled a veritable Garden of Eden, with trees "tantalizing to look at and (fruit) enjoyable to eat," as in the biblical paradise.

Pomona's Paradisiacal Offerings

On January 13, 1745, Frederick II gave the order to crown his vineyard with a "Lusthaus" (a "pleasure palace" serving the private pleasure of the owner). In 1746 it received the name "Sans Souci," and was ready for occupancy in the early summer of 1747. From that point on, whenever possible the king would decamp during the first warm days in May to his cheery summer residence, which was habitable until autumn. Here, he could step through double-wing doors that reached down to the ground and onto the terraces. In May his beloved fruit trees in the modern kitchen garden and among the continually expanding hedge gardens, were in full bloom, dominated by the dazzling white of the cherry blossoms. At the same time, the growing number of greenhouses in the park supplied the royal table and dishes displayed throughout the palace with fresh fruit, in order to delight the king at all times.

Frederick used his gardeners' skills and craftsmanship to satisfy his culinary predilection for unusual fruit. In the glasshouses, gardening skills triumphed over nature: irrespective of the seasons, fruit ripened on the trees all year round. Even exotic fruit such as melons, oranges and pineapples came to maturity, and from 1769 bananas and papayas were cultivated successfully. Frederick was known to pay any price for unusual fruit, motivating private gardeners around Potsdam to compete with the king's gardeners and to devote themselves to fruit cultivation in particular.

Whether the king was on a fact-finding mission or at the front, carefully wrapped fruit was sent to him, especially his beloved cherries. This extraordinary passion for fresh fruit was passed on to his successors. Only the very elaborate and costly cultivation of bananas and papayas was abandoned under Frederick William II, after which the building was used to store grapes and other fruit. However, the cultivation of pineapples was significantly expanded. With the accession of Frederick William II another fruit enthusiast came to the throne. When he entered Paris with his Prussian troops in April 1814, cherries, plums and strawberries from the greenhouses of Sanssouci were sent. These were admired, marveled at and in general enviously praised.

Italienisches Kulturstück, beds with artichokes, corn and chard

It was only in 1816, when Peter Joseph Lenné (1789–1866) became the garden director at Sanssouci, that fruit growing came briefly under threat of sacrifice to the concepts of English landscape gardening. Evolving me-thods of transport and the sweeping expansion of fruit cultivation around Potsdam meant the court no longer needed to rely solely on its own farm products. However, the king and his gardeners fought to prevent the sacrifice of all areas where fruit was grown to fashionable landscape gardening. Only the old kitchen garden was redesigned after 1840, retaining its original name, Marly Garden, losing its fruit trees in the process, but otherwise remaining true to its original design. The concept of combining beauty with utility, so typical of Frederician Sanssouci, was reinterpreted by Frederick William IV for the gardens surrounding the Roman Baths. This area was cultivated to reflect his yearning for the south, by planting specific plants and creating the kind of landscape experienced while traveling through Italy. Grapevines hung in garlands between poplars; corn, artichokes, Swiss chard and basil grew in the flower beds, incorporating the experience of the south in the royal cuisine.

The Golden Fruit of Sanssouci

Orange trees were afforded a special place in Sanssouci. As part of the movable garden stock, they could be arranged in a number of differ-

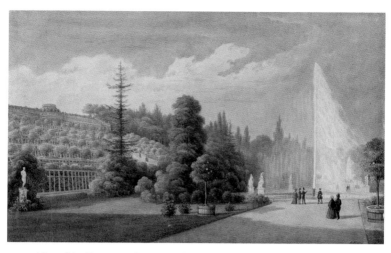

View of the Terraces at Sanssouci, before 1844

ent ways to suit the fashion of the time. Nevertheless, such delicate plants needed a place to hibernate, as a single night of frost could have killed them. Like the king and his summer residence, they only graced the terraces from May to September. The start of the summer season at Sanssouci was heralded with the festive liberation of these trees from their winter quarters, some of which resembled palaces. Apart from their striking beauty, fragrant flowers, evergreen foliage and golden fruit, it was the mythological references in western literature and art, especially since the Renaissance, that helped the orange to such great importance. Later, oranges would come to exemplify the desire of the North for the South, a development spurred on to no small degree by Goethe's "Song of Mignon," which was written in 1795.

In 1728, young Frederick had enviously inspected the glorious orange trees at Zwinger Palace, which his father had just sold to August the Strong. Once he became king, he did his utmost to amass his own collection of magnificent orange trees. At the beginning of the Seven Years' War there were supposedly around 1000 orange trees growing in Potsdam. Originally from Eastern Asia, and reaching the West around 300 BC, these plants had already been admired by Roman emperors. It was thought that they were the fruit that had once grown in the ancient garden of the divine Hesperides. The myth proclaims that only heroes and wise rulers who do good deeds for the greater good of humankind, and under whose rule a golden age, a

time of peace and economic prosperity can flourish, can possess this fruit.

In front of the Picture Gallery, there were also orange trees in precious, gilded pots or porcelain vases. Here, a historical connection between the nearby Oranier Rondel and bust of the Electress Louise Henriette can be established. Frederick II's great-grandmother, a princess from the Dutch royal house of Orange, had had her family's dynastic symbol, the orange, accepted at the court.

Frederick II's successors made use of the magnificent supply of orange trees in various ways. Frederick William II displayed Sanssouci's most beautiful examples in his New Garden at Heiliger See (Holy Lake). He had winter quarters heavy in symbolism specifically built for them, despite the skepticism of his gardening experts regarding their need for intensive care. The accession of King Frederick William II ushered in an even more intense involvement with this fruit. As the first Prussian king to travel through Italy and wander among the orange groves of Naples, on his return, he wished to repeat the experiences of his travels. In summer, he had the orange trees arranged in a grove surrounding the New Chambers; the gardeners were instructed to sink the tubs completely into the ground, to create the impression of orange trees growing naturally. His son, Frederick William IV, also an enthusiastic traveler to Italy, built the most beautiful winter quarters for Sanssouci's many orange trees, which are still in use today. The Orangery Palace, built from 1851–64, has Roman and Florentine elements. In large greenhouses under fresh green myrtle, laurel and orange tree leaves, even on a freezing winter's day, one can enjoy the scent of a southern paradise.

King and Potato

Before leaving Sanssouci's gardens, Frederick II's grave on the uppermost terrace is definitely worth visiting. In keeping with his last wish, after being reburied several times, he was eventually laid to rest here in August 1991. Soon after, visitors started to place potatoes on the sandstone tomb inscribed "Frederick the Great," as a way of thanking Frederick for the great historic act of introducing this "fruit of the earth" to Prussian soil; a wishful thought shaped since the 19th century by stories found in school books that portray this sovereign as the benevolent father of the country, who touchingly looked out for the well-being of his subjects. In fact, the potato had already been

Carl Daniel Freydanck, *Panorama of Sanssouci*, after 1845

introduced to Prussia in the 16th century, even though it was hardly cultivated. Frederick tried to change this with numerous edicts to establish a more reliable basic nutrition, in order to save the grain for times of war and for trading, and to prevent famines by being able to provide the people as well as livestock with these less expensive tubers. However, the humble potato failed to arrive in the gardens of Sanssouci or upon the king's table, and never became an apple of paradise.

The maiden pink blooms in the dry, nutrient-poor meadows at the New Palace

Sanssouci Park: Monument and Biotope

Birgit Seitz and Moritz von der Lippe

The design of 18th and 19th century landscape gardens often emulated an idealized image of nature, based on idyllic cultural landscapes, such as ancient Acadia. Even if these idealized landscapes were newly created in landscape gardens in the form of skillfully condensed and – as it were – staged versions of nature, their essential design elements were drawn from the cultural landscape of that period. As Peter Joseph Lenné began to redesign Sanssouci gardens in 1816, he found all of the vegetation elements needed for reshaping the landscape, such as flowering meadows interspersed with groves of trees, bodies of water with fitting flora, and smaller wooded areas, in the cultural landscape surrounding Potsdam. And their placement in the park's new arrangement was mostly done using techniques practiced at the time in regional agriculture and in gardening, as well as in the cultural landscape. In addition, the inclusion of vegetation from the local cultural and natural landscape in the garden design of large landscape parks, in particular, has resulted in its survival there. The biodiversity of natural surroundings established in the landscape gardens was thus no less biodiverse than that of the surrounding cultural landscape and even demonstrated more structural variation as a result of the condensed configuration of the landscape. These factors laid the foundation for the extraordinary importance of Sanssouci Park as a habitat for plants and animals in the modern day.

It is thanks to continuous and careful park maintenance, that the already special significance of nature conservation at Sanssouci, as at many other historical parks, could be greatly enhanced over time. The

enormous intensification of agriculture in the cultural landscape has led to a dramatic decline in the number of biodiverse meadows since the mid-20th century. At Sanssouci, on the other hand, the meadows are only mowed twice a year using traditional methods. And while modern forestry rarely tolerates old or dying trees on grounds of productivity, the Potsdam park landscape, with many of its aged giant trees still standing, has positively become a refuge for species originally found in primeval forest or in islands of old trees within the woodland.

Sanssouci Park thus represents more than just an outstanding garden monument within the Potsdam park landscape. From the perspective of nature conservation, it can be viewed as a large open-air museum, in which many, now very rare biotopes and species have been able to survive, independent of the intensification taking place in the cultural landscape. This has brought new challenges in the preservation and maintenance of the garden landmark. For, although the traditional methods of care and the retention of the original tree stock carried out according to conservation guidelines were initially responsible for the special qualities of the natural environment, these requirements can in detail also lead to increased coordination overhead in executing measures to preserve the historical garden. It is clear that a work of garden art with a 250-year history in the meantime exhibits a certain need for renewal. The old stock of trees, in particular, must be kept safe near paths and clearings to ensure the safety of visitors to the park. This situation involves continuous tradeoffs between the preservation of the historical stock of trees and their cautious renewal, in a process that now must also respect the concerns of nature conservation.

In the following, we would like to discuss the great significance of Sanssouci Park for nature conservation in terms of its most important biotopes, as well as their typical species and conditions of formation. We will also consider the historical buildings, which form an essential habitat for bats. In conclusion, we will address the particular challenges that arise in the process for cooperation between garden preservation and nature conservation.

Meadows

For most summer visitors to Sanssouci Park, the sight of flowering meadows full of color remains one their most memorable experi-

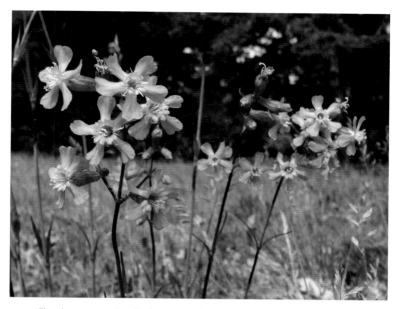

The clammy campion (*Lychnis viscaria*), critically endangered in Brandenburg, thrives unusually well in Sanssouci Park's meadows

ences. Indeed, the meadows and lawns at Sanssouci are among the most biodiverse and valuable grassland biotopes in Potsdam and its environs.

The absence of fertilizing allows species accustomed to nutrient-poor locations to prevail. Distinctive plants, such as clammy campion (*Lychnis viscaria*), prairie junegrass (*Koeleria macrantha*), and quaking grass (*Briza media*) are even relatively common in the park meadows. Closer observation reveals that the meadows have entirely different bloom aspects, depending on soil moisture and nutrients. Swampy ground, such as in the Hopfengarten (Hops Garden) and near the Roman Baths, will be home to the broad-leafed marsh orchid (*Dactylorhiza majalis*), holy grass (*Hierochloe hirta* subsp. *Praetermissa*), and devil's bit (*Succisa pratensis*). Cowslip (*Primula veris*) and prostrate speedwell (*Veronica prostrate*) bloom where the soil is particularly dry and hard, for instance along the edges of the pathways at the New Palace and in the Hopfengarten.

The nutrient-poor meadows at Sanssouci also offer habitat for many endangered meadow fungi, including wax caps, meadow clubs and corals, and earth tongues. In Brandenburg, there are very few "mushroom meadows" showing such a rich variety of fungi.

Bio-diverse wet meadow with broad-leafed marsh orchids

A botanical treasure from the nutrient-poor area along the pathways is the early star of Bethlehem (*Gagea bohemica*). The small, warmloving bulb blooms early in spring and was introduced in the early 19th century with gravel brought from Alt Töplitz on the Havel River to construct the footpaths. The plant, today an endangered species, was able to establish itself with time in the dry lawn areas along the paths and continues to endure at Sanssouci. It has meanwhile disappeared from its original growing area, and can only be found at a few other locations in Brandenburg along the Oder River.

The historical garden culture also left its mark on the meadows. For instance, at Sanssouci Park, as at many other historical parks, seed containing grasses and herbage from wild harvesting was used to sow the meadows. This seed often stemmed from other regions and coincidentally contained species that now serve to identify its origins. The earth chestnut (*Bunium bulbocastanum*), for example, comes from southern Germany, and is only found in Brandenburg at Sanssouci and one other location in southern part of the state. Outside of the meadows as well, species intentionally planted by gardeners to beautify the park in historical times have survived and spread. These are primarily bulbs, such as nodding star of Bethlehem (*Ornithogalum nutans*) or Siberian squill (*Scilla siberica*). These indicator plants from old garden culture are seldom seen outside of historical parks and cemeteries and are thus considered worthy of preservation in the view of both nature conservation and historical preservation equally.

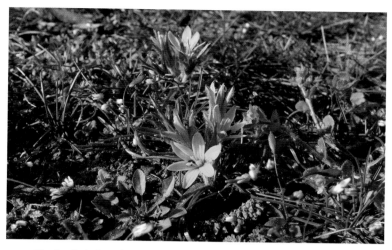

The tiny Early Star of Bethlehem (*Gagea bohemica*), endangered throughout Germany, blooms early in March along the pathways at the New Palace

Trees

Old trees appear at Sanssouci most commonly as solitary trees in the meadows, along promenades, or in outspread groves. Commercial forestry has no role to play in historical parks, so the trees have been able to age there in peace.

Trees of this size are rarely encountered beyond the borders of these institutions. Over time, many of these trees have developed hollow spaces, knotholes, and splits, which now represent valuable habitat for many animals, such as cavity-nesting birds, bats, wood-dwelling insects, and fungi. This diversity of old and dying timber has encouraged breeding in the park by three strictly protected species of woodpeckers, as well the tawny owl, with three breeding pairs at once. Old trees also serve as hunting lookouts for birds such as the pied flycatcher or the kingfisher, which has been seen for many years at the Maschinenteich (Machine Pond).

Some of the old oaks are home to larvae of the great Capricorn beetle, a beetle species strictly protected under European Union law. The hermit beetle has also been observed in the park. For these beetles' protection, it is important that old, dying trees not be felled, but allowed to age and die in peace – as long as they are not located near paths and do not represent a danger for park visitors. An effort is made at Sanssouci Park to maintain historic tree stock at its original growing site for as long as possible. This includes tall stubs, which

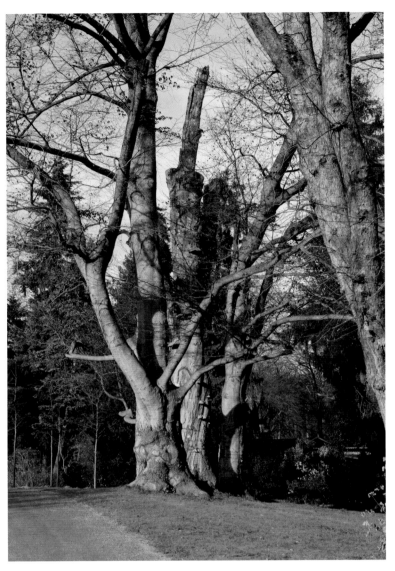

This grove of old and dying beeches is picturesque and also a habitat for numerous species

are dead trees whose crown and branches have been totally or largely removed for safety reasons.

The wooded sections of Sanssouci Park are comprised mostly of oaks, beeches, and hornbeams. Species of plants typical of the older forests, such as the various-leaved fescue (*Festuca heterophylla*) or the common hepatica (*Hepatica nobilis*) grow in the underbrush. Here, too,

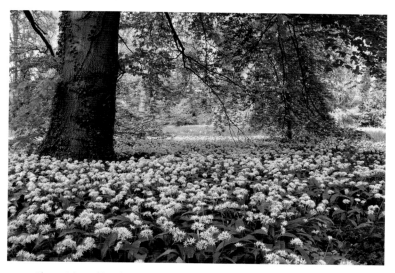

The patches of bear's garlic can be traced back to historical plantings

examples of indicator plants that have become wild can be found. For instance, bear's garlic (*Allium ursinum*), which is not native to Brandenburg, blankets areas in the spring, and can be traced back to historical plantings.

Buildings

The magnificent buildings and palaces in Sanssouci Park are a favorite refuge for a particularly endangered group of mammals, the bat. Sanssouci Palace's large moist cellar vault and six other buildings serve as winter quarters for six species of bats. The greater mouse-eared bat, protected under European Union law, and threatened with extinction in Brandenburg, winters in the Hofkolonnade cellars and under the Charlottenhof Palace terrace, while the pipistrel bat spends the winter under the stairways at the Jubiläumsfontäne (Jubilee Fountain) and in the protective coverings of the sculptures. Tree cavities also function as winter habitation. Seven species of bat use the park as hunting grounds during the summer. These include the serotine, soprano pipistrel, and nathusisus' bats. The common noctule bat set up its nursery roost near the Friedenskirche (Church of Peace).

All bats are strictly protected under the Federal Nature Conservation Act. This also applies to their roosts. Caution must be paid during renovations that entrance holes are not blocked. Bat habitat in trees must also be preserved during trimming and felling work.

Nature Conservation and Historical Preservation in Sanssouci Park

The fields of nature conservation and historical preservation, once combined under the umbrella of the cultural heritage protection movement, have each developed into specialized disciplines with their own instruments. Their areas of responsibilities and objects of protection often overlap at historical gardens. However, whatever difficulties may arise in the course of coordinating details, nature conservation and historical preservation are united by a common belief in protection. Continuing to maintain the meadows in the traditional manner is thus highly significant for both the historic visual impression within the park and its biodiversity. The nature conservation requirement that old trees be retained finds its counterpart in the approach taken by historical preservation to conserve original material as long as possible. The starting position for considering the goals of nature conservation and historical preservation jointly is therefore generally very good.

A higher level of coordination between both disciplines is often required when traffic safety concerns or the restoration of historical garden scenes necessitate more extensive renewal. Planting trees according to historical sources, for instance, or constructing pathways can threaten occurrences of rare plant species or biotopes. Up-to-date mappings of rare plants and biotope types carried out by the University of Potsdam (F. Hoelhl) and municipal and state agencies (Potsdam and Brandenburg) have made it possible to carry out strategic planning and measures in the park that are compatible with nature conservation and historical preservation guidelines. At Sanssouci Park, for example, the refurbishment and expansion of the footpaths at the New Palace was foregone, in favor of protecting the biodiverse areas along the existing paths.

The impact on rare species and biotopes can often be minimized through the use of innovative practices and protection measures during garden renewal. Possible adverse impact to the biodiverse dry lawn areas by construction in the course of rehabilitation work on the New Palace could not be entirely ruled out, so seed was proactively harvested in the form of grass cuttings and planted at other locations, for example on the Winzerberg (Vintner's Mount). After completion of work at the New Palace, the dry grass areas are to be restored with the saved seed.

In the future, successful communication, innovative solutions, and compromise will also be necessary on a case-by-case basis, to coordinate nature conservation and historic preservation concerns in the face of renewal demand that is tending to rise.

Design

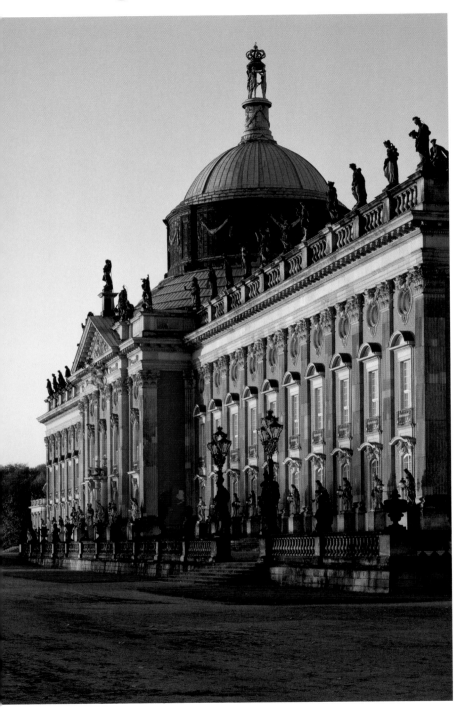

New Palace (1763–69), garden side, view from the north

The Moat in Sanssouci Park

Alexandra Schmöger

Von Tosberg's earliest engraving of the parterre, from 1746, shows a formal moat as boundary to the Pleasure Ground in the south. This originally also enclosed the Obelisk Portal in the east, but the waterway was extended to the west in the course of expanding the water displays in the park.

Frederick the Great had the New Palace erected at the end of the park's main thoroughfare, the Hauptallee, in 1763, after the end of the Seven Years' War. His "fanfaronade" or boast was intended to give architectural expression to Prussia's new importance in the European political arena.

The building materials were brought by ship: lime from Berlin and Ferch, marble from Silesia, and sandstone from Magdeburg and Pirna. Heinrich Ludwig Manger, the royal building advisor, reported in his building history of Potsdam from 1789 that transportation from the wharf on the Havel River to the construction site was very slow, because of a lack of wagons and draught horses.

The king's directive that construction occur as quickly as possible could not be followed, which led Frederick in 1763 to authorize deepening and reinforcing the already exiting waterway known as the Schaafsgraben (Sheep Trough) from the Havel River to the park boundary. This canal had connected the Havel River with a sophisticated mill near the still extant Meierei am Kuhtor building since 1748. The apparatus pumped water flowing from the Havel River to a reservoir on the Ruinenberg (Mount of Ruins) to supply the fountains in the park.

F. Albert Schwarz, *Potsdam, Sanssouci Park*, soil being transported to the ponds at the pheasantry for filling in the "Palaisgraben" (New Palace Moat), 1881

This canal was then extended 900 meters, directly to the New Palace construction site. In December 1764, the first freight barges could dock in the harbor basin, by the low wing on the south end of the New Palace. The canal, know as the Palaisgraben (New Palace Moat) played an important role in the swift completion of the New Palace by 1769. The waterway lost it function as a transportation route with the conclusion of construction.

The canal had already taken on a new significance in 1765, when Frederick the Great had it routed to the west of the Communs, so that it became a formal feature in the park. The waterway was run through the Deer Garden to the Schaafgraben. The canal system also served to drain the construction site's soggy terrain.

Two bridges crossed the moat to the palace grounds at the northern and southern gate buildings. Just a few remnants of the canal wall can still be found at the New Palace's southern gate building, while portions of the canal, wall, and bridge are still visible at the northern crossing site.

In spite of all efforts to the contrary, the Palaisgraben tended to stagnate, rather than flow, which soon led to complaints about

Erdarbeiten
beim Neuen Palais und in Sanssouci bei Potsdam
ausgeführt 1881 von Davy, Donath & Co. (Berlin).

Zuschüttung des Palaisgrabens.

Soil for filling in the "Palaisgraben" (New Palace Moat); the two trains used were the most modern means of transport available at the time

unpleasant odors. With Frederick William and Victoria's relocation of their residence to the New Palace in 1859, the aggravation of foul odors increased even more because of waste water from the New Palace being fed into the canal. "Unhealthy fumes" were also the reason why this waterway, also known as the New Canal, was filled in, with the work lasting from 1878–81. The needed fill was transported over a two-track railway line laid from the town of Eiche in the west. Paul Artelt, imperial chief engineer under William II, questioned the filling of the canal in his treatise on the waterworks and water displays at Sanssouci, because of the loss of needed drainage. Attempts to solve this problem by laying clay pipes were later initiated.

The Colonnade at the New Palace

Gerd Schurig

The extensive construction measures carried out at the New Palace from 1763–69 also included the ensemble comprised of the Communs and the Colonnade, to the western edge of the park. All design elements – horticultural and architectural, spatial and two-dimensional – are subject to strict representational symmetry and regularity. The Palace Theater and Prince Henry's Wing at the New Palace are located across from the two massive, three-story Communs service buildings with their palace-like façades, at a distance of about a hundred meters. The sculptures on the attic and the gilded "brides of the winds" on the domes correspond to the graces and other figurative decorations on the palace, and serve to heighten the effect of the larger building. Intentionally kept undecorated and flat in design, the courtyard between them is dominated by sections paved with local Mopke bricks – for which this intermediate space is named – sunken grassy areas, and sandstone bollards.

The entire area around the New Palace, including the large garden parterre to the east, a fruit orchard surrounded by hedges, groves of trees, the Hedge Theater, the latticework Gitter Salon, and gardeners' buildings, was surrounded by a moat. Seven bridges connected the space with the older Sanssouci Park and the surrounding landscape.

To the west, a colonnade forms an impressive link between the two Communs buildings. Carl von Gontard, from Bayreuth, built the structure, intended to serve as an architectural backdrop, according to plans by Jean Laurent Le Geay. Two flanking pavilions form

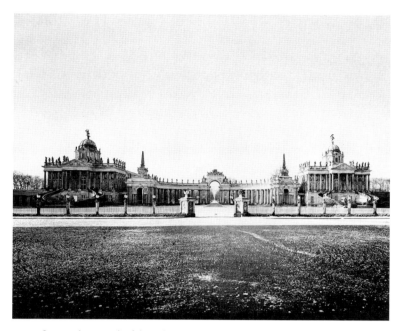

Survey photograph of the Colonnade from the east, c. 1930

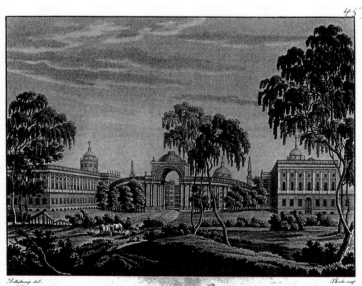

Die Communs und Colonade | Les communs et la Colonade
beim neuen Palais bei Potsdam. | près du nouveau Palais près de Potsdam.

View from the west of the Colonnade in 1824, C. F. Thiele, *Rear View of the Communs at the New Palace*

the points of contact to the large utility buildings formerly used as a kitchen and servants' living quarters. They are connected to the triumphal arch with its large rounded opening by a sweeping, semicircular colonnade. The portal was originally crowned with an obelisk, like the pavilions. Attic figures on the cornice above each pair of columns again complement the sculptural ornamentation.

Along the axis, the view is drawn through the large triumphal arch into the surrounding landscape of the Golmer Luch, a boggy area. As on the central section of the New Palace, individual gilt attributes stand out. The center path leads over a small bridge and was initially a double promenade just 700 meters long, conceived as an extension of Sanssouci's main thoroughfare, the Hauptallee. It was first competed with three pathways separated by four rows of trees and a length of two kilometers in 1866. In spite of the inviting semicircular gesture and the columns' promise of a vista, the colonnade was originally conceived of more as a type of termination than a connection to the environs. Chestnuts were planted behind the spaces between the pairs of columns, with some of the trees still standing until after World War II. The landscape and the areas used for agriculture were likely considered unattractive and in need of concealment, so the colonnade was chosen as an urban closure of the space.

The Frederician Hedge Theater at the New Palace

Michael Rohde

In 1765, Frederick the Great began the construction of the Hedge Theater together with that of the New Palace. The green outdoor theater fits in with the setting of the pompous, summery New Palace, used for festivities and as a guest palace, as well as the geometrically shaped Baroque gardens. For the court's festive programs, the iron "Gitter Salon" (a pavilion enclosed by latticework) was created as a southern counterpart for staging musical events.

During the Rococo period society's relationship to nature changed. The surrounding landscape was discovered and vividly included; gardens became living and festive spaces. Hence the wooded Deer Garden became one of many areas Frederick used to create contrast for further staged settings and interpretations; from the Hedge Theater one also gazes upon the Dragon House with its exotic Chinese design and the Belvedere in the Italian-English Palladian style on a distant hill.

Here the Frederician bond between garden architecture and sculptures comes alive. The sculptures in front of the hedges, such as the marble bust of a faun, are from the Bayreuth collection of Frederick's sister Wilhelmine, who died in 1758.

Frederick had already built the Opera House in Berlin and had begun early to integrate theaters into his palaces. His affection for music and literature is almost tangible and has been harnessed in the surrounding landscape. In a letter from Rheinsberg in 1738 he writes about these pleasant occupations: it is the "music, comedies and tragedies that we stage, the masquerades and feasts we hold."

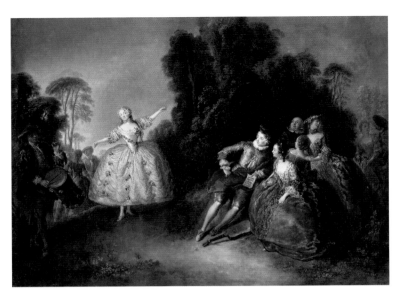

Antoine Pesne, *A Pleasant Society* or *Mademoiselle Cochois Dancing*, 1745

In March 2009 the Freunde Preußische Schlösser und Gärten e.V. decided to recreate this long-lost garden with donations. In May 2012, on Frederick's 300th birthday, the Hedge Theater at the New Palace ceremoniously reopened with the premiere of Voltaire's *Candide; or, Optimism* attended by 300 guests.

The Royal Rose Garden in Sanssouci Park – Empress Augusta Victoria's Self-Expression and Self-Conception as a Gardener

Alexandra Schmöger

The recently married royal couple, Frederick William and Victoria, the crown prince and princess, lived at the New Palace at their own request as of 1859. Summers, the family made the palace the center point of their lives, until the death of Frederick (III), now emperor, in 1888. In addition to necessary renovations and modernizations to the palace, maintenance and alterations were also carried out in the surrounding garden areas beginning in 1862. When the court gardener Emil Sello was visiting London in 1866, Queen Victoria told him that her daughter, the crown princess, had dedicated herself to studying horticulture since early adolescence. Consequently, it is not surprising that Victoria personally involved herself in the design of the gardens surrounding the New Palace.

Until his death in 1866, the royal garden director Peter Joseph Lenné maintained supervision over the gardens of the crown prince and princess at the New Palace. Lenné had to approve of all changes and any work. However, after Lenné's death, King William I agreed to a request by the garden director, Graf von Keller, that granted the royal couple far-reaching independence in the design of the gardens at the New Palace. From then on, Sello could directly implement Victoria's gardening instructions. She favored modern English garden design and methods of cultivation.

Contemporaries praised the garden grounds, whose arrangement, unfortunately, can no longer be fully traced. In addition to her conceptual input, emphasis was placed on the "noble lady's" practical gardening activities, which motivated her children and husband

A magical impression of the garden with its plethora of roses, as described by Theodor Nietner, with garlands of roses in the foreground

to do gardening as well. Thus, in 1881, Heinrich Wagener, a teacher at Potsdam's Garnisonschule, reported that Victoria chose the trees from the tree nursery herself and had her sons plant them according to her directions. The children were also given their own section of the orchard, where after tending to garden work – such as planting, grafting the various sorts of fruit, and watering – they were allowed to pick and enjoy the fruit.

The crown princess devoted special attention to the design of her private gardens. Wagener writes that these lay in the hedge gardens, in close proximity to the northern wing of the New Palace, which served as the family's summer residence. These plots that had been laid out during Frederick the Great's reign for growing fruit had become unproductive farmed land, which was first converted into a children's playground and then a rose garden.

In his treatise *Die Rose* (The Rose), dedicated to the crown princess, the court gardener Theodor Nietner describes the rose garden in exacting detail. Nietner reported that when the roses blossomed the entire garden made a truly fairylike impression. Roses grew in low flowerbeds, climbing roses intertwined arbors, and long-stemmed standards were planted along the main paths. Climbing roses also entwined the standards, or were hung from tree to tree as festoons.

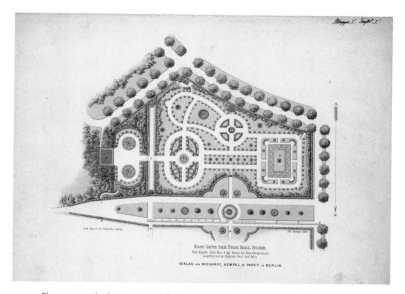

The geometrical structure of the garden is easily recognized in Nietner's map. The family gathered for tea in the Little Teahouse (marked *g*). Theodor Nietner, *Sanssouci Park, New Palace, Rose Garden*, 1877

The graceful rose garlands were introduced in Germany under Victoria and recommended by Nietner for imitation.

Today, only the base of a marble sculpture of Empress Augusta Victoria erected in 1906 remains in this area that her son William II had turned into a private garden.

The Iconographic Program of the Marble Statues on the New Palace's Bordering Parterre

Saskia Hüneke

The Semicircular Rondel is one of the most impressive attestations to King Frederick II of Prussia's (1713–1786) turn to antiquity, which he also regarded as a basis for the intellectual discussions of his times. He loved classical literature and used the ancient myths to express political, philosophical, and also very personal messages in symbolic and encoded ways. Moreover, antiquities were especially suited to identifying their owner as an art connoisseur.

The 14 over life-sized ancient statues were acquired in Rome from 1766–68. They had been "restored" by the sculptor Bartolomeo Cavaceppi (1716–1799), which at that time also meant that interpretive modifications and additions were carried out.

Subjects associated with pleasure, the arts and health were brought together in the Rondel's southern quadrant, which begins opposite the King's Apartment. According to their 18th century descriptions, the sculptures represent an athlete grooming himself, a goddess of fertility, a faun, a dancing girl, Apollo with his lyre, a muse, and Asclepius, the god of health. In the northern quadrant, opposite the wing for court ladies-in-waiting, are figures of Antinous sacrificing himself, the dutiful Juno, a fighting athlete, Cleopatra sacrificing herself, and Apollo with the punished Marsyas; subjects which can symbolize duty, struggle and punishment.

The statues were given to Berlin's Königliche Museum (Royal Museum) in 1830 and marble copies later replaced them in the Semicircular Rondel. However, the new sculptures of the athletes were realized in such a way that some of the content-related associations

Eduard Stützel, *Athlete with Ointment Jar* (based on a classical model), 1858
Frederick II's display of sculptures was altered in the 19th century. This depiction
of an athlete is one of several marble copies showing enhancements made to
original statues. The ointment jar in the figure's right hand was added to the orig-
inal sculpture in 1828. The copy was installed in the northern quarter of the
circle rather than at the location of the original in the southern quarter.

of the works have been lost. Three statues of girls with enhancements
had to be put in storage for conservational reasons. Nevertheless,
it is rewarding to trace the concept in which Frederick II may have
reflected his own conflicting attitudes caught between "duty and
personal affinities."

Eduard Stützel, et al., *Antinous* and *Asclepius* with snake attributes symbolizing health, *Urania with the Globe of the World*, *Apollo Lyceus with Kithara* (all based on classical models), 1852–57, Semicircular Rondel at the New Palace

The Marble Sculptures in Sanssouci Park: Care and Preservation

Kathrin Lange

Most of the sculptures in Sanssouci Park are made of Carrara marble, a material favored since antiquity for momentous sculptures. Having been exposed to the elements for 180 to 250 years, their present condition is problematic and present restorers, curators and conservationists with serious challenges.

Different types of weathering are apparent on the marble sculptures in the park, external weathering leading to the loss of the original surface. During industrialized periods with heavy air pollution damage was caused by acid rain and the deposition of aggressive black crusts.

A noticeable change over the last 15 years has been an increase in biological colonization due to a decrease in air pollution. Apart from their obvious effect on the surface, the biological and chemical weathering processes created by algae, lichen, fungi and mosses also affect the layers below. This kind of destruction is typical in marble, where these layers are literally torn apart by the so-called anisotropic behavior of calcite crystals under thermal exposure. They lose cohesion, the surface cracks, making the entire sculpture vulnerable.

Maintenance is particularly important in preserving an ensemble of sculptures and has been carried out in Sanssouci Park with few interruptions since the 18th century. This tradition of "Puppenbürsten" (brushing the dolls), i.e. simply washing off loose particles of dirt on the marble's surface is one of the most important measures. This regular checkup ensures that the restorer catches any changes in the sculpture's appearance as soon as possible.

Weathering of the marble surface (by several millimeters) next to hard, more weather-resistant marble veins, 1993

A familiar feature of the park's winter landscape and an important measure to protect the sculptures during winter, from *Totensonntag* (the Sunday of the Dead) to Easter, is the enclosure of each statue in a light gray box. This protects them from damage by incessant autumnal rain, as well as bouts of snow and frost.

Biological incrustation on a marble surface, 2009

The sculptures are examined with ultrasound to provide an initial assessment of the condition of the marble. Repetition over time records the progression of any structural disintegration.

Depending on the results, more intensive measures of conservation and restoration may be needed. This may involve the strengthening of decaying areas, injection and closure of fissures, restoration of broken-off minutiae, or treatment with a pesticide. Final measures may even entail full conservation, where loosened calcite structures are bonded together with acrylic resin; if necessary, replacing the original with a copy. If an original is too fragile to withstand the out-

Lambert Sigisbert Adam, *Water*, 1749, marble copy by Peter Flade (2004–11)

door elements, it is exhibited indoors as an important work of art instead. To maintain the integrity, contextual reference and overall aesthetic effect of the ensemble, a copy of the original (made of the same substance) is put in its place. In recent years, the most important project of this kind has been the rescue of the marble sculptures

circling the Great Fountain in Sanssouci Park, and the reestablishment of the ensemble with marble copies of the originals.

Cultivation

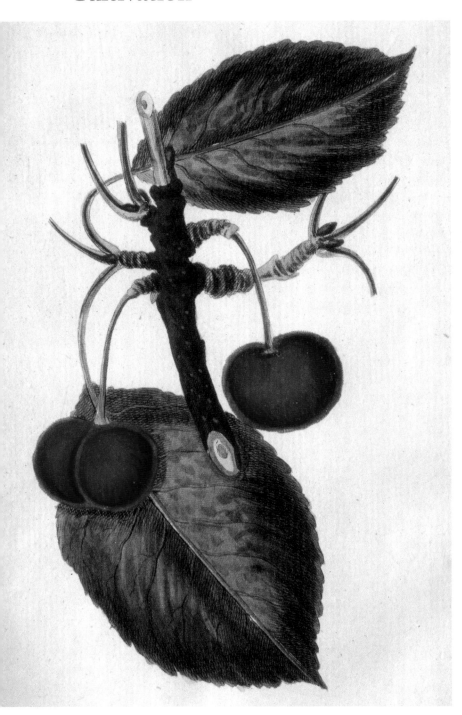

Double Natte Cherry, *Allgemeines Teutsches Gartenmagazin*, 1809

Fruit Cultivation in Sanssouci Park

Gerd Schurig

During the reign of Frederick the Great, the fruit culture in Prussia flourished in all respects. The estates in Neuruppin and Rheinsberg, where he had spent time as crown prince, had already had large nurseries and he began work in Potsdam on the vineyard terraces shortly after taking the throne. A whole series of other nurseries and plots under cultivation within the park would follow. In addition to various vineyards, orangeries, greenhouses, and cold frames, there were independent sections dedicated to the cultivation of pineapples, melons, bananas, and papayas. Furthermore, the king's wish for fresh fruit throughout the year and willingness to a pay a high premium for it motivated his and other gardeners to have their fruit trees bear particularly early. This led to the ambitious introduction of forced growing patterns for fruit and vegetables at Sanssouci, accompanied by the entire array of necessary greenhouses. At the time of Frederick's death, eight court gardeners specialized in this area with its very modern equipment. An unusual feature of the garden's design was its dedication of large portions of the property to open-air cultivation. Fruit trees were grown behind hedges (as in the case of the Cherry Orchard now recreated below the New Chambers), stood in small orchards in the Deer Garden, and trellised along the garden's outer wall and in the copse near the Chinese House.

The nurseries were kept up and continuously modernized under Frederick's successors, for the later kings and emperors did not want to forego the delicious and prestigious fruit. After the monarchy ended, the properties – now museums – lacked the funding nec-

Friedrich Christian Glume, male and female *Bacchantes* on the garden façade of Sanssouci Palace, 1746

essary for continued operation. The means of transportation was also now faster and more efficient, so the number of expensive nurseries with their specialized staff could be greatly reduced.

In addition to artistic traces on buildings, garden accessories, and a decorative sculpture that documents this interest in horticulture, it is still possible with adequate information to find a variety of historical evidence. The Picture Gallery, for instance, was created by

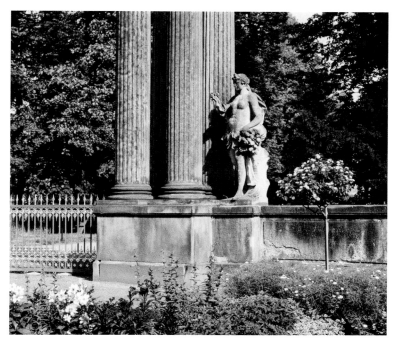

Friedrich Christian Glume, *Pomona with Fruit* at the Sanssouci's Obelisk Portal, 1747 (copy from 1963)

converting the first greenhouse while basically retaining the building's original dimensions, with the Orangery similarly becoming the New Chambers. In that case, the original use – with its orientation to the sun – is still recognizable in the windows reaching almost to the floor. In the present-day botanical garden at the University of Potsdam, the large greenhouse complex in the terraced area from 1912 has survived, as has the former court Gardner's House. In the vineyards on the Winzerberg and the Klausberg, two enterprising associations are engaged in operating from the setting in a historically appropriate manner.

The Eastern Pleasure Ground

Jörg Wacker

In 1747, Frederick the Great had a large hothouse constructed on the hill to the east of Sanssouci's terraces. Built to let in the maximum amount of sunlight, it was used for cultivating southern fruit and vegetables. He also had vegetables planted in the terraced garden area in front of the building the following year. From 1755–63, the hothouse was converted into the Picture Gallery. Joachim Ludwig Heydert (1716–1794) erected the grotto-work terrace wall and laid out the Holländischer Garten (Dutch Garden) in front of it to the south. This garden's main decorative features included a semicircular *parterre d'emaile* comprised of pruned boxwood patterns and colored glass coral, gilded vases for the orange trees and porcelain vases in front of the terrace, as well as two *berceaux* (pergolas) with salon-like spaces, all of which served to conceal from view the remaining fruit orchards at their sides. The difference in height to the Hauptallee (main thoroughfare) was offset by the Puttenmauer (Cherub Wall), built in 1764.

Portrait busts of the House of Orange created in 1650 were set up in the rondel around the fountain basin on the Hauptallee in 1748, and radial paths at regular intervals run between broad, salon-like spaces. The eight corresponding garden plots used for the cultivation of fruit and vegetables were edged with topiary hedges. Six compartments for fruit cultivation were laid out and lined with topiary hedges within a rhomboidal path structure in 1748, below the future site of the Neptune Grotto (1751–57). The Mohrenrondell (Rondel of Moors) with its ancient busts is located on the Hauptallee and forms the center of this Pleasure Ground.

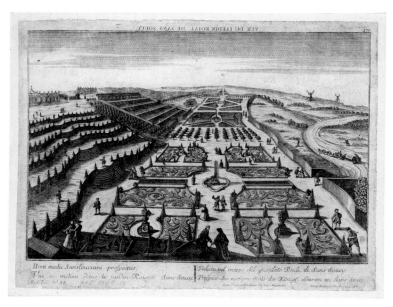

Georg Balthasar Probst, *Prospect des mittlern theils des Königl. Gartens zu Sans-Soucy*, c. 1748, colored copperplate engraving. Probst's engraving is an idealized representation of the Large Parterre, behind which are fruit orchards enclosed by hedges, as well as the terraced kitchen garden in front of the hothouse (converted into the Picture Gallery from 1755–63

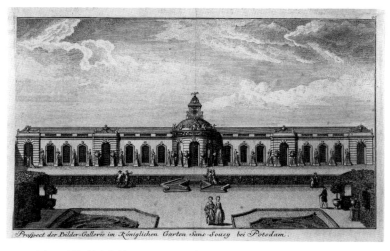

Johann Friedrich Schleuen, *Prospect der Bilder-Galerie im Königlichen Garten Sans-Souci bei Potsdam*, before 1769. The "Perspective of the Picture Gallery in the Royal Garden of 'Sans-Souci' near Potsdam" as seen from below the terrace of the Holländische Garten (Dutch Garden) with its semicircular parterre and berceaux.

A semicircular parterre with two lawn areas bordered by flowerbeds and augmented by a series of twelve busts lies in front of the Obelisk Portal, also erected in 1747–48. This entrance gate's dedication to garden design is clearly expressed in the sculptures of the goddesses Flora and Pomona. Standing at the midpoint of the parterre, the view to the east used to look through a total of ten radially planted Linden avenues that took in particularly outstanding architecture within this former municipal center of Potsdam. The obelisk, installed in the same period, marks the symbolic beginning of Sanssouci Park's Hauptallee.

Plans currently being made for the restoration of the Holländischer Garten include planting fruit in the hedge-lined compartments and restoring the parterre at the Obelisk Portal.

A Fantasy in Stone – The Neptune Grotto in Sanssouci Park

Frank Kallensee

All moving bodies of water, wellsprings, wind and weather fell into Neptune's domain. He was a powerful god for the Romans. They equated him with the Greek god Poseidon and believed he ruled over the oceans. Water was Neptune's element and the realm of water was where he should naturally remain in Potsdam. The Neptune Grotto, constructed from 1751–57, was part of the "water arts" that Frederick the Great (1712–1786) planned for Sanssouci Park. Unfortunately, the king never saw a display of flowing water at Sanssouci. Pumps operated by steam power in the "Mosque" on the Havel River would first make that possible in 1842.

Nonetheless, the Neptune Grotto, which stems from a long tradition of European grottos and fountain structures, represents the architect Georg Wenzeslaus von Knobelsdorff's (1699–1753) last creation for Sanssouci. It was not completed until after his death. Such structures had been described in the literature of antiquity and had belonged to the repertoire of garden design at least since the era of Renaissance parks in Italy and France. Knobelsdorff was familiar with the "grotto fashion" from firsthand experience. The style also inspired fanciful engravings, in which the architectural imagination seemed to know no limitations.

Knobelsdorff designed a tripartite façade with gently curving, elegantly recessed side sections and a tremendous portal at its center. Four Ionic columns provide its support. A marble Neptune with his trident, standing among dolphins, triumphs atop the strongly contoured cornice. The sculpture is a work by Johann Peter Benkert

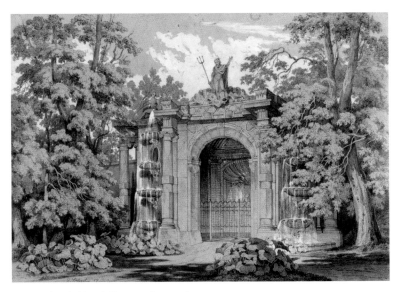

Julius Schlegel, *Neptune Grotto*, 1857

(1709–1765). The three-dimensional shell and reed decorations in the interior of the grotto also bear the signature of this master, who had been active in Potsdam since 1744. The god is flanked right and left by naiads (water nymphs), created by the sculptor Georg Franz Ebenhech (1710–1757), who had been called from Saxony to the Prussian court. Water was intended to flow from jugs held by the naiads into four, console-like bowls stacked one below the other, which have been transformed into shell-shaped basins, in the true spirit of Ovid's *Metamorphoses*.

Knobelsdorff did not conceive the Neptune Grotto as a solitary building, but as a component of garden scenery in – what for the Baroque period – was an unusual hill setting. Its climax, even today, can be seen in Sanssouci Palace with its terraces. The Neptune Grotto is a perfect example of the connection that the 18th century sought to establish between architecture and nature.

The fact that Potsdam's Neptune mostly spent most of his time presiding over a dry realm did not, however, prevent weather and water from plaguing the brick and mortar structure with its exterior decoration of with Carrara and Kauffung marble. Extensive renovations had already been necessary in 1841. Moisture seeping through the faulty roof caused substantial loss to the rare grotto-work in the 1960s. The sculptures, which were seriously damaged by vandalism,

Grotto-work in the Neptune Grotto

were finally rescued from further harm in the 1970s. Despite these hardships, the grotto is now being repaired, thanks to generous private donations and the support of the joint venture "Potsdamer Schlössernacht" (Potsdam Palace Nights). And so, Neptune will be returning to his element at last.

The Importance of Sanssouci Park for the Quality of Life in the City

Michael Rohde

Old royal parks not only evoke memories of the glory of former royal seats, but also offer a high level of recreational and educational culture. During the Enlightenment and with the emergence of an urban middle class at the end of the 18th century, royal parks were opened to the general public, and communal promenades, city parks, and green space slowly evolved. People's relationships with nature changed. With the conception of a multifunctional park for the people, "decorative green" became "healthy green."

Industrialization since the 19th century brought increased manufacturing and population growth, some improvements notwithstanding. The negative health impact of urbanization and overcrowding in the cities remains an issue. City residents suffer from noise, dust, and heat. Mobility, increasing tourism, and wasteful practices bring about other problems. Climate change just increases the risks.

Sanssouci Park provides Potsdam, the capital of Brandenburg, not only with recreation and education opportunities, but with other significant services as well. The health of the municipal population is improved by the park's ability to counterbalance urban heat stress through its production of fresh air (CO_2 absorption) and regulation of temperature.

The substantial green mass of the old and young plantings in Sanssouci Park and the cultivated landscapes of Berlin and Potsdam as a whole serve in no small way to purify the air, by binding fine particulate and other air pollutants. Noise emissions can be buffered to some extent. The green space of the nearby park has also been shown

Flowering meadow along the moat in Sanssouci Park

to alleviate stress and other health problems, while increasing people's sense of well-being.

The natural experience in Sanssouci Park facilitates environmental education in a variety of ways and provides "green classrooms" for young and old. The park thus contributes to the vitality of the ecosystem. Joint projects involving historic preservation and nature conservation are initiated regularly, ranging from species protection (meadows) and habitat preservation (old growth trees) to counteracting the effects of extreme weather (controlling water flows in the park during heavy rain).

The Large Parterre at Sanssouci

Jörg Wacker

Below the vineyard terraces created in 1744 is a parterre, whose land-scaping was concluded in 1764. Matching the width of the terraces, the parterre extended to the park moat, which was reinforced with limestone and accompanying yew hedging. At the center of the par-terre with its eight compartments stood a quatrefoil-shaped fountain surrounded by marble statues from the French school, displaying a gilded *Thetis* figural group. Four mosaic-like sections with bands of colored minerals, grass, and boxwood ringed the basin to form a *par-terre de broderie*. *Tapis verts* (strips of closely-mown lawn) formed the middle axis to the palace. The two outer segments on either side of the Hauptallee (main thoroughfare) were laid out in the style of a *parterre d'anglais* as slightly deeper lawns, with gilded sculptures at their centers, encircled by intersecting paths. All the sections of the parterre were surrounded by *plates bandes* (flowerbed borders) and punctuated by yew pyramids. In the 18th century, the original eight compartments of the parterre were combined into four. Following the installation of a large circular fountain basin in 1842, they were densely planted with trees, especially those with colored leaves.

In deference to the marble semicircular benches inserted around the fountain basin in 1847, it was decided to forego a renewal of the *broderie* in the smaller inner compartments. The partial recrea-tion begun in 1927 was not completed until 1998. A lawn subdivided with yew pyramids still remains. The surrounding flowerbed borders were only laid out again in the four outer compartments. These beds are annually filled with more than 22,100 bulbs and plants for the

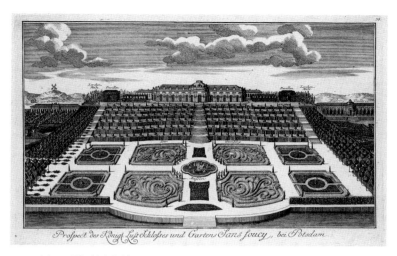

Johann Friedrich Schleuen, *Prospect des Königl. Lust Schlosses und Gartens Sans soucy, bei Potsdam*, c. 1756. The etching provides an impression of the magnificent Large Parterre with a fountain basin at its center, the *tapis verts* aligned with the axis to the palace, the four *broderie de parterre* segments and two *boulin grains*, each flanking the outer perimeter.

spring flower displays and with approximately 15,000 summer flowers grown in the park nursery.

The Cherry Orchard in Front of the New Chambers

Jörg Wacker

In 1747, Frederick the Great had an orangery built to the west of the Sanssouci terraces, which was subsequently converted into the New Chambers from 1771–74. From the terrace in front, a ramp leads to the cherry orchard, which since 1750 has been grouped into four sections intersected by a crossroads. Until 1812, cherries and plums grew on these grounds, which were enclosed by topiary hedges.

In 1937, work was begun to reverse the changes made to the landscape during the 19th century, restoring the former Baroque design with its crossroads and two *berceaux* (pergolas) to the south. From 1955–74, there was a rose garden in this square, which was gradually abandoned due to historic preservation guidelines. The surrounding hornbeam hedges were planted as recently as 2002, and from 2005–08 a total of 147 sweet and sour cherries were planted as low and half standards in a diagonal direction across the four sections.

The traditionally grown sour cherry varieties *Werdersche Glaskirsche* (Werder glass cherry) and *Schattenmorelle* (morello cherry) were grafted onto rock cherry (*Prunus mahaleb*) rootstock, whereas the sweet cherry varieties *Spanische Knorpelkirsche* (Spanish cartilaginous cherry), *Frühe Werdersche Herzkirsche* (early heart cherry from Werder), *Kassins frühe Herzknorpel* (Kassin's early cartilaginous cherry), *Schneiders späte Knorpelkirsch* (Schneider's late cartilaginous cherry), *Große schwarze Knorpel* (large black cartilaginous), and *Werdersche Braune* (brown cherry from Werder), were grafted onto wild cherry rootstock (*Prunus avium*).

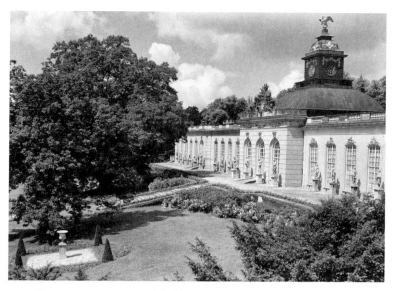

The upper compartments of the Cherry Orchard with solitary trees dating from re-landscaping in 1878, and the Rose Garden in front of the New Chambers, laid out in 1955–56

In 2013, 82 trellis and 28 pyramid cherry trees were planted; 36 sour cherry trees were planted in the first row adjacent to the terrace wall and are being grown on so-called Lepère palmettes or fan espaliers. The second row consists of 21 simple sour cherry fan espaliers, the third row of 25 sweet cherries grown as candelabra espaliers, and the fourth row of sweet cherries shaped into pyramids. Not only does the Cherry Orchard provide visitors with an impression of Frederick's wide-ranging passion for fruit growing; it also furnishes the SPSG's gardens with unique examples of differing historical espalier shapes.

The Sicilian and Nordic Gardens

Jörg Wacker

From 1856–61, Frederick William IV had two orangeries and kitchen gardens that had held their ground since the middle of the18th century replaced by two gardens built to the south and the north of the Maulbeerallee and to the west of the New Chambers, according to designs by Peter Joseph Lenné. They are a mere fragment of the tremendous "Triumphstraße," or triumphal road project envisioned by the king, which was to connect the vineyard in the north of Sanssouci Park with the Belvedere on Klausberg, lined by Italianate buildings.

In addition, in front of a planned guesthouse there was to be a terraced garden stretching out above the Maulbeerallee, which was to be furnished with architectural elements from Italian Renaissance villas and gardens. Around 1856, a sandstone wall with rounded corners and a marble balustrade with descending, symmetrical ramps was built to the south of the tree-lined Maulbeerallee. Below the fountain set in the center of the sustaining wall lies the symmetrical "Italian Garden." It has a circular centerpiece framed by two curved pergolas with square, regularly spaced openings, which surround a quatrefoil-shaped pond. This area was lavishly furnished with Mediterranean and other southern plants grown in tubs and pots and soon came to be known as the "Sicilian Garden." The dwarf palms, New Zealand flax ferns and wood ferns in the midsection are surrounded by twelve flower beds shaped like star points that have been planted with white, blue and red flowers. Twelve circular flower beds pick up these colors, leading to borders planted with pampas grass and hosta. European *arbor vitae* grow on the exterior of the curved pergo-

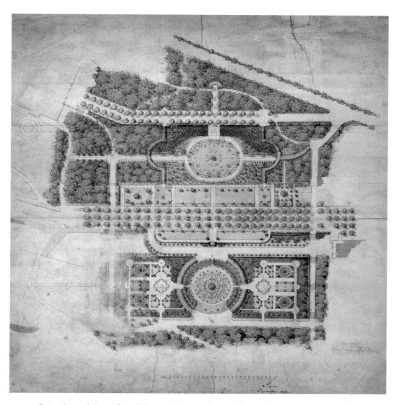

Peter Joseph Lenné and Gustav Meyer, the Nordic and Sicilian Gardens (as implemented), before 1865

las, their shape resembling the column-like form of the less frost-resistant cypress tree. In the section on the eastern side exotic conifers and in the western section deciduous woods were planted together with evergreens and boxwood. Paths affording specific views were created above the supporting wall and marble balustrade that were embellished with palms in tubs. The western section was completed in 1866 with a pergola.

Because the nearby Orangery Palace, which was already under construction, already included enough rooms for guests, Frederick William IV relinquished the idea of building a guesthouse. Hence, above the Maulbeerallee, the Nordic Garden was conceived in 1860–61 as a counterpart to the Sicilian Garden. On a round centerpiece, where rare conifers once grew, bordered by beds of regularly planted roses and other flowers, a grotto with a scenic view from the terrace arises from a steep embankment. From its sides symmetri-

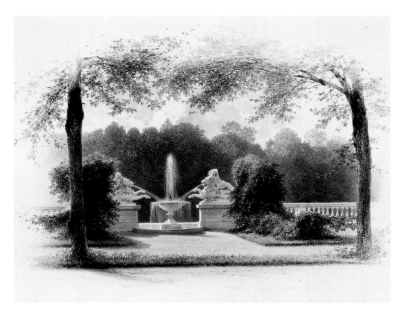

Carl Graeb, *Balustrade Wall with Fountain in the Sicilian Garden*, c. 1863.
Fountain with two leonine sea creatures, as seen from the viewing balustrade
of the terrace wall above the Sicilian Garden on the Maulbeerallee, with
wooded groves trimmed into spheres, bushes, and festoons on the flanking
lawns

cal paths once part of a covered arbor lead down to a pergola in front
of an old forcing wall (a fruit growing wall used for cherries) and up
to the Triumphstraße. Evergreen shrubs and in particular densely
planted conifers of the Pinetum variety characterize this garden. A
special feature are the two dioecious ginkgo trees that were planted
when the garden was first created: the female stands at the east and
the male at the west of the central section.

The Sicilian Garden was restored from 2000–04, and the recon-
struction of the centerpiece in the Nordic Garden is being planned.
Its geographic orientation, as well as the way in which the plants and
sculptures have been incorporated, do justice to the north-south con-
trast. Both gardens embody the concept of using plants to emphasize
geography, heralding something previously unseen in the history of
19th century garden design on the European continent.

Sicilian Garden in Sanssouci Park with the mill and the historical windmill in the background

Francesco Menghi, *Ildefonso Group* (marble copy based on a classical model), 1837

The "Theaterweg" in Charlottenhof Park

Gerd Schurig

Every well-designed garden is somewhat like a walkable picture gallery. The paths serve as an exhibition concept, defining and presenting a compelling series of intentionally contrasting scenes in accordance with client wishes and the garden designer's ability.

In the process, portions of views may also remain intentionally obscured, to create a frame or to pique curiosity for closer investigation. As is usually the case, a distinction is also made at Charlottenhof between the gently curving, comfortable walkways for quick access to the main attractions and the smaller, more demanding paths for a slower, more intense experience and exploration of the garden's hidden charms. The Theaterweg (Theater Way), which constitutes the shortest way from the New Palace to Charlottenhof, is of the former category. The quicker forward progress demands that the series of garden vistas be presented at greater intervals. Those interested in other, more intimate details of the Charlottenhof garden are encouraged to also try the smaller paths.

Visitors who have discovered the deep enjoyment of the park vistas as they change with the seasons and times of day, individually and in combination with each other, will soon also notice the sites along the paths offering the best view of the garden arrangement. A first indication is the benches at historically suitable locations. A perfectly arranged garden invites us to linger and enjoy the surroundings. The next point of interest is the areas surrounding path intersections and forks, where there are commonly numerous vistas of near and distant garden attractions, which perhaps divert us from our originally

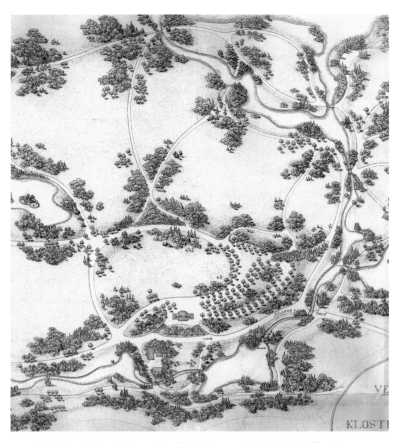

Peter Joseph Lenné, *Map of the Klosterbergegarten Public Park* (from *Verhandlungen des Vereins zur Beförderung des Gartenbaues in den Königlich Preußischen Staaten*, Vol. II, Berlin 1826, plate IX)

chosen direction. Bridges or slight elevations also offer the scenery in overview, or doubled, as a reflection in the water. Sudden bends in the pathways are generally motivated by visual foci. Longer straight sections are also typically oriented toward a garden attraction, which compensates for the path's lack of variation. Finally, the interplay of light and shadow should be taken as a clever hint. Leaving the shade of the trees, the eye needs a moment to adjust to the sudden brightness, and there, at the point of pausing, the visitor is again presented with a choice of vistas. Here, as elsewhere, the view is never completely free, but partially obscured by woods, to increase our interest in discovery. The approach to a chosen destination seldom occurs along a straight line of view, but often over side paths and always with

Temple of Friendship in a meadow

Meadow with the Sun Pavilion in the background

the possibility that the goal or route may change. It is also interesting to note, that a path and garden will present themselves in an entirely new guise, when walked in the opposite direction.

A visitor taking a relaxed walk along the Theaterweg, furnished with these insights and aware that looking back can have its rewards, will be able to experience the diverse and captivating scenes, just as in a theater. The Theaterweg, however, did not receive its colloquial name on this account, but because it is the shortest route from the entrance of Charlottenhof to the royal theater in the New Palace.

The Role and Care of Tree Clumps in the Park

Michael Rohde

Groups of 20 to 30 trees of various species, also known as clumps, are characteristic elements of the landscaped garden. Beginning in the second half of the 18th century, gardens and parks were designed to look like a natural landscape. This entirely new style in park design, which created idealized natural settings based on the principals of landscape painting, marked the end of the architectural phase associated with the Baroque and Rococo periods. That new organizing principal of the aesthetic of tree grove arrangement relates primarily to the composition and framing of visual axes, including the use of picturesque trees and flowering scrubs to create a variety of forms and colors, as well as an impression of contrast and space.

The woods planted in Sanssouci Park under the guidance of Peter Joseph Lenné can still be enjoyed some two hundred years later. In Charlottenhof Park grove-like nearer sections consisting of scrubs and solitary trees, for instance, set off groups of trees in the extensive meadows. Some of these clumps have been replanted and need about twenty years to unfurl their intended artistic effect. Walks along the winding paths laid out by Lenné lead through open, brighter sections interspersed with shaded areas.

The noticeable acceleration of climate change has added a new dimension to park maintenance. Weather extremes such as harsher late-winter frosts (cold snaps) and increasing summer dryness are becoming a threatening factor. Shortages of water during the bud break will increase. At the same time, milder winters are causing leaf development and flowering to begin ever earlier. Drought stress

Both illustrations from: Hermann von Pückler-Muskau, *Andeutungen über Land-schaftsgärtnerei, verbunden mit der Beschreibung ihrer praktischen Anwendung in Muskau*, compendium, Stuttgart, 1834

increases, while warm-loving plants and animals migrate into the area, including harmful ones as well.

Practices to preserve the stock of old trees and any replacements in accordance with conservation guidelines must be reconsidered. With this in mind, the SPSG will be hosting an international conference sponsored by the Deutsche Bundesstiftung Umwelt (DBU – German Federal Environmental Foundation) in September 2014.

In recent years, the SPSG has also begun addressing the effects of climate change from a scientific standpoint. In cooperation with numerous research institutions, it has developed adaptation measures for the preservation of the historical gardens listed as UNESCO World Heritage. These efforts can be observed throughout Sanssouci Park in the form of areas laid out as study or demonstration plots. Visitors to these sites during the "Paradiesapfel" garden show will be able to learn about current research into the conservation and care of trees, bushes, meadows, and flowers. The project is intended to point out that the gardens are more than just an exceptionally creative example of cultural history and of publicly accessible educational institutions. They also represent valuable ecological systems that store water, act as a cooling buffer, provide a reservoir of fresh air, bind carbon dioxide, and offer valuable habitat to both flora and fauna. The gardens positively influence the surrounding urban areas and consequently the lives of the people there.

The Play of Water at Charlottenhof

Jürgen Luh

Construction of the palace and gardens at Charlottenhof began in 1825 for the crown prince of Prussia, Frederick William (reigned as King William IV from 1840 until his death in 1861). Karl Frederick Schinkel (1751–1841) designed the architecture and interior of the small summer palace, and Peter Joseph Lenné drew up the plans for the surrounding landscape garden, connecting it in the north to Sanssouci Park. Lenné introduced an entirely new appearance to the previously flat, sandy, and partially swampy grounds. In his layout for the park, Lenné focused on the east-west axis formed by Schinkel's architecture, reinforcing it through his alignment of fountains, pools, and water displays. They were intended to symbolize the different phases of life, as well as to recall the recurring need for intellectual reflection and mental renewal. The play of water continues to be a characteristic element of the palace and park.

The source of Charlottenhof's water displays was to be found at the most eastern point of the terrace in front of the palace. Here, on the banks of the Machinenteich (Machine Pond) and concealed beneath a viewing platform, was a steam engine that pumped the water needed to bring the fountains to life. Only the chimney of this technical innovation could be seen from the terrace, in the form of a simple column. Efforts were also undertaken to obscure this. A semicircular bench under a vine-covered pergola in the form of tent (still extant) fulfills this task.

In underground pipes the required water runs first through the low-lying landscape created by Lenné and then beneath the Rose Gar-

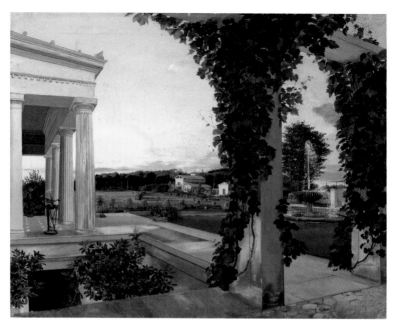

August Wilhelm Ferdinand Schirmer, *View from Charlottenhof Palace to the Court Gardener's Villa* (Roman Baths), 1831

den planted along the palace axis between the Exedra and the Dampf-maschinenhaus (Steam Engine Building) in 1835. It surfaces at two locations there: in the arbor it spouts forth from the mouth of a boyish satyr kneeling over an amphora atop a column, a sculpture in the original by Christian Daniel Rauch. It then accumulates in an ancient sarcophagus at the southern terrace wall. On the higher terrace, it flows up into a large dish-like receptacle visible from the distance, where it gushes into the air before draining over the fluted edges in regularly spaced rivulets into the central basin below it.

From there, the water flows along two narrow channels to the west and east into two semicircular pools. To the north, the terrace slopes gently down to a large rectangular pool with a semi-circular widening along its northern side. In its middle, a bust of Crown Princess Elisabeth surveys the entire terrace from a tall column. Looking longingly to the south, she is able to follow the progress of the sun over the course of an entire day. What she sees should bring pleasure and convey clarity, vitality, and joy.

To the palace's west the water again flows underground in the direction of the Dichterhain (Poets' Grove), where it resurfaces in the

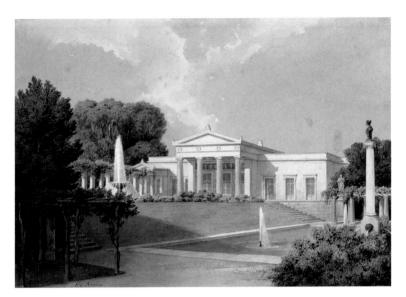

Ferdinand von Arnim, *The Water Displays in Front of Charlottenhof Palace*, watercolor, c. 1845

Neptunbrunnen (Neptune Fountain). It has been said that the flow of the water here manifests its inherent underworldly nature (Cf. Schönemann, Charlottenhof). The course of the water concludes in the Stibadium of the Hippodrome, where it rises into the sky one last time in a high fountain.

The Historical Significance of Rose Gardens and the Rose Garden at Charlottenhof

Michael Seiler

The first roses were cultivated in China more than 4000 years ago. They bloomed in the gardens of Babylon, in ancient Greece, in Rome, in the Arabic world, and also in Europe as of the Middle Ages. The role that they played in religion, myth, poetry and art – and still do in the present day – is hard to fathom. The pentagonal shape of a rose's simple flower, with its reference to the number φ, also added an essential element. The rose has always been an indispensable component of every flower garden. The number of types and varieties, however, was initially so limited that the idea of presenting roses in specialized gardens did not come into fashion until the beginning of the 19th century. The impetus for this was the introduction in Europe of the Bengali Rose at the end of the 18th century. Cross-breeding of this import with traditional European roses resulted in an assortment previously unknown, creating a virtual firework of new rose varieties that caught the attention of eager breeders and collectors alike. Empress Josephine was an especially passionate rose enthusiast, who by 1814 had collected 250 different sorts in her garden at Malmaison near Paris.

France was initially the center of rose breeding in the 19th century, followed by England, Germany and the United States – a development that can be traced in the names of the types of roses. Rose gardens sprang up in parks throughout Europe that enacted this dynamism between collection and artistic presentation in great diversity. The first rose garden in Prussia was laid out on Peacock Island in 1821, based on a design by Peter Joseph Lenné. The free-flow-

G. Koeber, map of *Charlottenhof or Siam* with its Rose Garden (detail), lithograph, 1839

ing, labyrinthine design of this rose garden fully corresponded to the Romantic idea of the rose as the flower of "confusing love." Fourteen years after designing the grounds on Peacock Island, in 1835 Lenné was presented with the opportunity to create a completely different style of rose garden at Charlottenhof Palace, in dialogue with Schinkel's palace, and based on geometric gardens recalling ancient models. In the interim, Lenné had also become familiar with geometrically arranged rose gardens on his trip to England in 1822. In his book on roses, Theodor Nietner, who was responsible for the Rose Garden at Charlottenhof from 1869–80, wrote that mornings and evenings were the most beautiful times to visit its rose garden. Lenné's two rose gardens, with their linear expansions set in an east-westerly direction, seem to oblige.

The chance to look out over a rose garden from an elevated standpoint was also considered ideal. At Charlottenhof it was possible to do so by the additional effect of the rising and setting sun. Mornings, the rose garden could be viewed from the observation platform of its Steam Engine Building. Constructed according to plans by Schinkel that aligned it to the axis of the palace, it was torn down in 1923. The view can still be enjoyed from the height of the palace terrace and the stairs leading to the Rose Garden. Twice as long as it is wide, it is bisected in the middle where it is expanded by four concentric circu-

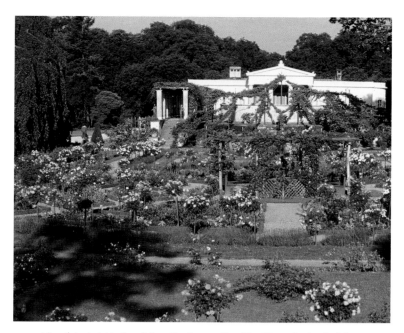

View (at a height of 4 m) from the former site of the Steam Engine Building over the Rose Garden at Charlottenhof

lar paths interspersed with rosebeds that circle a central arbor. Seen from above, its length and width appear to be in balance. The Rose Garden had to be abandoned in 1880 due to soil exhaustion. When it was being recreated from 1995–97, only roses that were known before 1880 were planted in its beds.

Long-Grass Meadows as a Biotope in Sanssouci Park and the Impact of Mowing

Tim Peschel

"Nothing grows without care." These words from Peter Joseph Lenné stem from a text he wrote in 1823 on the founding of the Königliche Landesbaumschule (royal tree farm) near Potsdam. Although he was referring to the care of trees, his idea also applies to meadows, as another essential component of historical landscape gardens. In contrast to the regularly cut areas of short grass near the palace in the Pleasure Grounds, they are only mowed twice a year and are referred to as long-grass meadows.

The well-known garden theoretician C. C. L. Hirschfeld, writing in his five-volume *Theory of Garden Art* from 1779, regarded meadows as those elements in a landscape garden that recall "lovely pictures of an Arcadian, pastoral world." In a way, meadows are the botanical embodiment of a simple, but happy country life. With their wealth of rare types of plants, variety of different types of grassland, and beauty, they remain for some conservationists and park visitors a type of Arcadian, natural place, a relict from the golden age, when nature supposedly was still intact.

This impression is true insofar as the majority of meadows are features of Central Europe's preindustrial cultural landscape that have become very rare in our present-day environment. The existence of a direct cultural and functional interconnection between the landscape, its use, and its living organisms make it little surprise, then, that the landscape gardens, in particular, are refuges for such types of vegetation. The long-standing, continuous use here of cultivation practices that seem old-fashioned from our perspective has

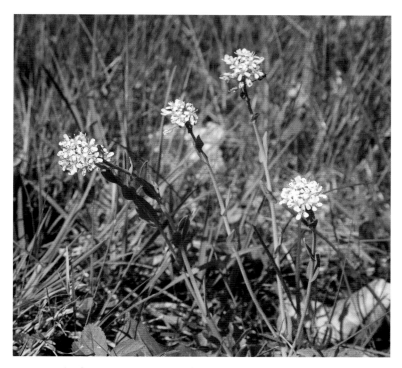

A spring feature: meadow cowslip (*Primula veris*) in bloom to the east of the New Palace

had the unintended side effect, as it were, of preserving many endangered species and types of meadows.

What is obvious in the case of the buildings also applies to the botanical components of Sanssouci Park. They are products of their time and could, therefore, only survive until now with traditional methods of care. The factors recognized to pose the biggest threat to many types of grassland, such as change of use (generally intensification), plowing, and conversion, play almost no role in the park. The lack of pressure to utilize the park grasslands agriculturally eliminates the need to apply large amounts of fertilizer and to maximize the hay harvest through early and late mowing. There is also no inclination to invest heavily in reducing local variation.

As a result, a very special type of botanical heritage could be preserved as well. A group of plants specific to landscape gardens found its way into Sanssouci Park as non-native grass seed or its contamination by the beginning of the 20th century. Some of these species were able to establish themselves permanently and have become a charac-

Long-grass meadow at the end of May with meadow buttercups (*Ranunculus acris*) in bloom to the east of the Chinese House

teristic of the old park meadows that distinguishes these areas from agriculturally used meadows outside of the park. With their ongoing presence as specific indicator plants, these non-native species provide evidence of a historical method of seed production and its specific application in landscape gardens. Their association with a distinct phase of garden design practice makes them culturally and historically particularly valuable. They represent a cultural heritage, just as historical buildings do, and should be recognized as such.

A Piece of Italian Culture

Gerd Schurig

In 1825, a section of agricultural land bordering Sanssouci Park south of Ökonomieweg was purchased for the crown prince, Frederick William. The following year, the young Hermann Sello was hired as the gardener responsible for its development at the recommendation of Peter Joseph Lenné, and the first landscaping work began.

Whereas the fundamental features of the large park grounds chosen by Lenné were based on the classical landscaped garden, here regularly-shaped parcels in a style typical of northern Italy were laid out in the areas surrounding the new construction. The ensemble comprising the Gardener's House and Roman Baths begun in 1829 was intended to give the impression of a well-organized northern Italian estate from the Renaissance, as a deliberate contrast to the environs of Sanssouci Palace, with their allusions to antiquity. In combination with the arrangement of the buildings and details such as roof form, pergolas, spolia decorations, and color scheme, the landscaping of the adjacent grounds contributed greatly to this effect.

Particularly striking in this regard was the recreation of Italian horticulture west of the Roman Baths, on the other side of main path. Hermann Sello had already presented the first plans in 1832, but their discussion by Frederick William and his confidant Baron von Rumohr would delay implementation for over a year.

Consequently, the first tree planting and construction of walkways began in the spring of 1834. The entire garden parcel was separated from the main park by a natural rose hedge. A series of cultivated patches arranged on slightly curving paths were placed along the

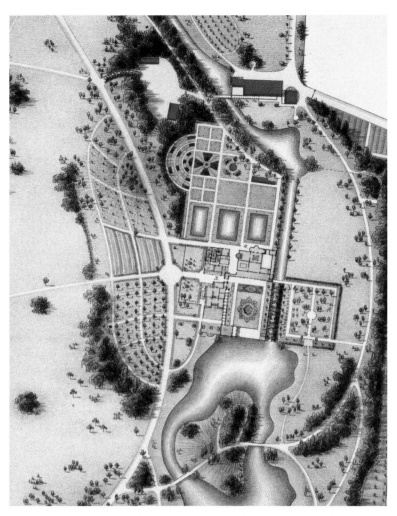

G. Koeber, map of *Charlottenhof or Siam*, 1839. Depiction of the "Italienisches Kulturstück" on a detail of the "Siam Map"

contours between two small elevations. An entire range of southern methods of cultivation and crop plants known at the time were to be found there. On the hilltops, for instance, stood groves of locust trees, with their southern European appearance and hard wood favored for trellising grape vines, which here grew down along the slope to the south. Fields were planted in the lower sections, with contemporary accounts telling of corn, artichokes, cardoon, and giant cane growing there. Historical information also indicates plantings of sea kale, eggplant, and a variety of southern squashes, such as zucchini

Grapevines growing among the mulberries at an old plantation in Veneto

and pattypan. The plot perimeters shown on the accompanying map may have consisted of fruit bushes. Adjoining to the south was an airy grove of mixed deciduous trees, comprising elms, mulberries, ashes, chestnuts, and rowans, with their crowns kept small by pruning. Small festoons looped from trunk to trunk, supporting grape vines and gourds. This section, in particular, exuded a foreign character, which, however, does not seem so unusual if compared with northern Italian agricultural operations still run in the traditional manner. Historical sources also mention various fruit trees, including figs and mulberries. That these were planted in the southern most corner of the Italian horticultural area can be deduced from the dense planting of trees there and its protection against possible late frosts.

Another Italian detail was the watering system. Water overflowing from a round basin mounted almost flush with ground on each of the two rises may have been used for direct irrigation of the plants in need, as in southern countries, or perhaps guided to them along water-saturated ropes.

Unfortunately, this charming section of the garden disappeared just 30 years after its inception because of the high maintenance required. Its former size, however, can still be detected by means of the rose hedge in the meadow.

From Flowered Chambers and Landscaped Interiors:
The Garden in the Interior, 1740–1860

Searching for Paradise Lost:
The Garden in the Interior

Michaela Völkel

"Gardening seems but a pale shadow and cameo of how we imagine our ancestors to have lived before the Fall when they were still innocent and in the paradise of the Garden of Eden" – in 1682, Wolf Helmhardt von Hohberg summarized in a few words of his widely read *Georgica Curiosa* a debate that had raged almost unchanged for centuries: only where Nature appeared as a *locus amoenus* (a safe place) could human beings come close to their concept of an ideal, pre-civilized primitive state. Archetypes of this ideal are the Garden of Eden on the one hand, which humankind has longed for since being cast out, as well as the Golden Age extolled since Hesiod (8th–7th cent. BC) on the other, which marks the mythological beginning of the history of civilization. In both, it is always spring, there is neither war nor hardship, trees and shrubs provide enough food for all, and cohabitation between human beings and animals is so peaceful, that it needs no laws or anthropogenic intervention. "Fear and punishment were yet unknown ... safe without soldiers, the population was carefree and lived calmly." (Ovid, *Metamorphoses* 1.89–113)

Forged into an idyll, this image has persisted in poetry since the age of the Roman Empire. Virgil's (70–19 BC) Arcadia and the *locus amoenus*, extolled by many a poet in antiquity, that delightful place on a flowering meadow, next to a spring under shady trees, kept alive the longing for precisely such a place of calm and insouciance for centuries.

However, as Arcadia remains mere fiction, this longing cannot be satisfied, and – at least in this earthly life – a return to Paradise or the Golden Age is impossible. Nevertheless, the images of a peaceful

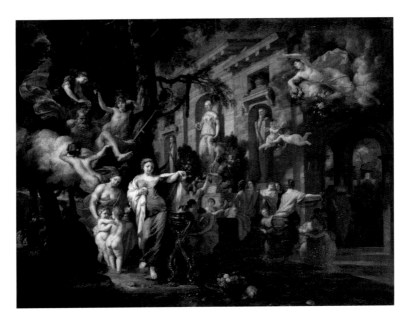

Gérard de Lairesse, *The Golden Age* (detail), c. 1667–70

life within and beside nature had ingrained themselves into the collective consciousness for good. In search of some aspect of this lost paradise, fragments were unearthed in different places and epochs. For instance, since the mid-18th century it was believed that the last traces of an ideal, pre-anthopogenic primal state had been discovered in isolated non-European cultures. At the same time, followers of Jean-Jacques Rousseau envisaged society returning to a more natural state of behavior in a future which would be uncorrupted by the deformations of civilization.

The plans for political and ethical life formulated by Cicero, Virgil, Horace and, at a later date, Pliny the Younger, can also be understood as the echo of a mythical state of innocence in a free and peaceful nature. In their poetry and letters these writers juxtaposed the life of the town dweller, encumbered by daily business dealings and the struggle to survive (*negotium*), with a more secluded way of life on a rural estate, dedicated to carefully chosen leisurely tasks (*otium*). To reach a balance between work and life, self-reflection and productive work, it is essential to be able to retreat from time to time to one's country manor and gardens, where conventions, aggravations, noise and haste are far removed, as in the Golden Age. "Here there is no

Oval Cabinet at the New Palace, c. 1767

need for a toga, no one attempting to take advantage of me. Everything is calm and quiet, in a healthy environment, the sky is clear, the air magnificent. Here my body and soul feel at their best ... Nobody denigrates anyone in my presence with base talk, I myself do not reproach anyone, but myself, when I fail to write skillfully; neither hope nor fear plagues me, there is no chitchat to agitate me; I only converse with myself and my books. Oh pure, unadulterated life." (Pliny the Younger, Book V, VI and I, IX)

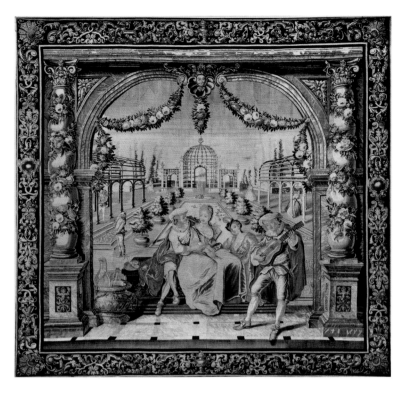

Charles Vigne, *Tapestry Series with a View onto a Baroque Garden* (detail), c. 1740

The garden theorists and experts on ceremonial customs of the early modern age continued in this vein when they counseled that their regent spend time in the garden, as he could "take care of his health / sequestered from treacherous people / ... to be content with few / to wait for deeper thoughts unhindered by obstacles." (Winckelmann, *Frühlingslust*, 1656, p. 187). Christian Cay Lorenz Hirschfeld also paraphrases the rural life advocated by the ancients, when he glorifies the garden as the "source of refreshment from anguish that calms all passions, [and] offers respite from all toil, the most delightful of occupations for humankind...[and the] refuge of philosophy." (Hirschfeld, *Gartenkunst*, vol. 1, 1780, p. 154). Even Voltaire's Candide cannot bypass the familiar topos in his rejection of idealism: At the end of the novel, which has seen the protagonist embark on an odyssey of different philosophical speculations in his search for happiness, Candide realizes: "that all of this [was] important, but that we

must cultivate our garden": i.e. to content ourselves with a modest, but real existence. When Frederick II cites this sentence repeatedly in his letters with reference to the end of the Seven Years' War, one hears the voice of a king humbled by the knowledge of the cost of a victory won by war. The gardens surrounding the New Palace, which were created immediately following this war, appear in another light in this context.

Tahiti or "la Nouvelle Cythère," where in 1773 Georg Forster believed he had found the last outpost of a paradisiacal, primal state, as seen from Berlin or Potsdam, was far removed – and gardens as "representation[s] of that beatific and joyful life / which our ancestors enjoyed in their innocent state in Paradise" – were not suitable as permanent dwellings, due to inevitable changes in the weather. Hence gardens – and before long Tahiti – were brought inside the roofed and heated indoors. The demarcations of these enveloping spaces were blurred through the use of illusions created by decorative art invoking a *locus amoenus* under the open sky. Already in the age of the early Roman emperors, murals depicting flowers and trees under an azure sky had permitted the inhabitants of these spaces to forget that they were in fact indoors. Starting in Italy in the 15th century, illusionistic murals transformed interior spaces into *al fresco* loggias with a 360-degree view of the outdoors. The ceiling frescos of the 16th century afforded views of open skies or pergolas entwined with the tendrils of climbing plants; 17th century tapestries that sought to achieve a similar effect are also known. First attempts in the 1660s–70s to dissolve the boundaries of walls and ceilings, by applying *trompe l'oeil* to their surfaces and transforming them into pergolas, survive to this day. Since the 18th century, wallpaper painted and imprinted with landscape and garden motifs created the illusion of being outdoors. The stuccoed trellises and espaliers of the Rococo period, however, only appear to nod towards the out of doors gardens, rather than create a deceptive facsimile.

Characteristically, almost all these kinds of transformed indoor spaces in the early Modern Age are found in country manors, villas and palaces, i.e. venues that offered retreat as opposed to following duty: "The residence of the regent at his *maisons de plaisance* and country mansions is beneficial. A private person takes pleasure in changing venue: how much more does one wish for a regent, that he be able to unburden himself from time to time." (Moser, Hofrecht II 1761,

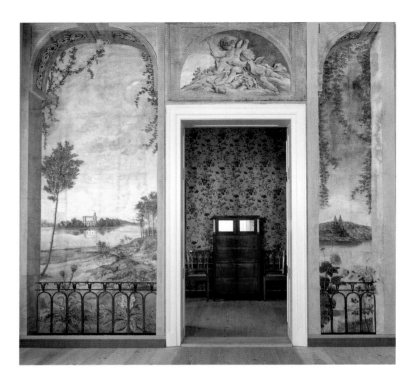

Painted landscape wallpaper in Queen Luise's living room at Paretz Palace, 1797

265). In the palace itself it was the spaces dedicated to *otium* in particular – that is to say the garden halls, *studioli* (cabinets; small study rooms or libraries) and dining rooms, and in Frederician palaces the concert rooms as well – that were interpreted as garden spaces. While these are to be understood as an artificial extension of outdoor space, cabinets, which were conceived as garden interiors, are based upon the classical topos by which study and self-discovery are considered to be most available in the solitude of a country estate or a *locus amoenus*. If spending time outdoors was considered to be conducive to philosophizing, dining *al fresco* on the other hand had always been a simple pleasure. "One attempted to hold banquets in amusing places / under huts in the outdoors / in gardens and orchards / [and] in this manner to divert guests further." (Harsdörffer, *Trancierbuch*, 1665, cited in Bursche, 1974, p. 44)

If one longed to dine "outdoors" in winter, an order was issued to the gardeners to "decorate the dining room with different kinds of

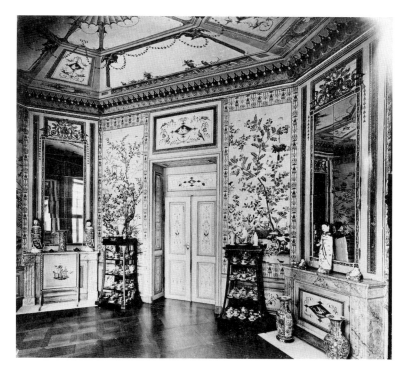

Frederick William II's dining room in the Summer Apartment in the New Wing at Charlottenburg Palace, 1788

green fir branches or juniper leaves / and to pleasantly integrate the orangery and flower pots among them," hence to bring the garden inside. (Marperger, *Küchendictionarium*, 1716, p. 531) It was thus only natural that the dining room be transformed into a garden space with more hardy and more permanent decorative elements.

Ultimately, the imitation of nature in interior spaces touches upon the relationship between nature and art. At one end of the scale there is the use of real plants, as art starts to make its influence felt where flowers are preserved in such a way "that they represent fresh [blooms] ...[with] artful diligence," with the help of which the "corporal shell of the flower itself / that is to say / the deceptive shadow of an evanescent and frail thing / which can live no longer than a day is quite alive and everlasting." (*Georgica Curiosa*, 1682, p. 860) At the other end of the scale we discover flowers sculpted from porcelain, so lifelike and easy to scent artificially, that art seems to be competing with nature. Referring to the imitation of nature in architecture,

Francesco Algarotti declared: "che del vero più bella è la menzogna" – that the lie is more beautiful than the truth. (Algarotti, *Versuch*, 1769, p. 189)

Vase and Cover, Embellished with Snowball Blossoms, Birds, Fruit and Insects

Regardless of the symbolism, this well-crafted imitation stands on its own and is a delight to behold. Vessels in the Chinese style such as these were first produced in Meissen in 1739, opulently covered in snowball bush blossoms. The body of this vase is densely covered by individual flowers intertwined with branches, from which the eponymous snowball blossom clusters seem to grow. The sculptor Johann Joachim Kaendler placed naturalistically painted birds and insects among the flowers.

The entire vase is a *tour de force* of European porcelain craftsmanship, which seeks not only to surpass its East Asian paragon, but even nature itself. Emulation of nature has been one objective of art since antiquity, and the question of how this should be done has been intensively discussed, in particular during the Italian Renaissance. Whereas for some the paradigm of imitating nature lay in the challenge of producing a deceptively lifelike match between the work of art and the subject being portrayed, others considered it important to emphasize the creative power of the artist, so similar in nature to nature itself, and advised that emulation, the hidden ideals of nature should be revealed.

The former were able to base their argument on an anecdote about the Greek painter Zeuxis (5–4th cent. BC) as told by Pliny the Elder, according to whom Zeuxis painted grapes that were so close to nature that birds would swoop down and peck at them. Without a doubt, visitors to the New Palace, who have had the pleasure of being able to study the Snowball Vase up close since the era of Frederick II,

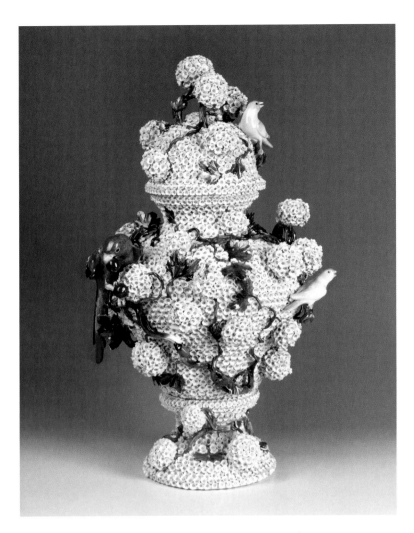

Johann Joachim Kaendler, vase and cover, Meissen, c. 1760

can point to the cherry-eating parrot perched on the vase's surface in support of one of art's most famous legends.

Michaela Völkel

"The Witty Paraphrase of a Pergola" – Treillage, Espaliers and Palm Trees: Decorative Elements of Frederician Interior Design

Claudia Meckel

The combination of Rocaille – design using shell-like forms that gave Rococo its name – sparingly mixed with nature and garden motifs characterizes the ornamental interior decoration of Frederician Rococo. How easily the vineyard and its tendril-covered espaliers, and garden with its trellises and flower garlands have found their way into the decoration of Frederick the Great's palaces in Sanssouci Park! Here the traditional theme of the pergola, used in interior design since antiquity, is an expression of the longed for retreat to nature and is represented by interior designs that are unique for the Rococo period.

Frederick the Great called Sanssouci Palace his *vigne* (French for vine and vineyard). In the *Encyclopédie ou Dictionnaire raisonné des sciences* by Diderot and d'Alembert (1751–81, vol. XVI) the first entry for *vigne* emphasizes the term *treille*: a canopy covered in vines. The term *treillage* (trellis), derived from this word, describes an open framework structure of intersecting vertical and horizontal supports. It is used to prop up and train espaliers, and cordon off sections of the garden. There are *treillages* shaped like arcades or *cabinets*, recalling images of gardens of paradise or gardens of love, which from the 15th to 17th centuries were used for banquets, and the performance of music and plays. In his standard reference *De la distribution des maisons de plaisance et de la décoration des édifices en général* (1738, vol. II), Jacques François Blondel recommends that wise property owners choose artificial trellises made of wood or iron slats. This was *de rigeur* for Sanssouci. In the palace's concert room, the combination of the lattice-like decorations

Johann Christian Hoppenhaupt the Younger, New Palace
Theater, cross-section, 1766

framing the mirrors, their flowers draped across them, and the espalier and trellis embellishments on the ceiling, create the impression of a *salon de treillage*. Their gilded appearance distances them from reality, which conforms to the ornate relationship of Rococo to nature.

Like other rooms at the New Palace (built 20 years later), we again encounter the *treillage* motif on the mirrors in the Marble Gallery, which was used as a dining room. In keeping with the idea of synthesizing all the arts into one harmonious entity, it was also continued in the decoration of the porcelain dinner service. The artificial atmosphere of the garden also prevails in the theater, where the balustrades have been given a veneer of latticework, creating the impression of an open-air theater. The palm trees adjoining the stage call to mind those in the Chinese House in the park.

The palm tree was a defining decorative element for Frederick the Great's era. The sculptor Johann August Nahl introduced it to German interior decoration in conjunction with *chinoiserie*, the European interpretation of Chinese-style decoration. The other main masters of Frederician Rococo, Georg Wenceslaus von Knobelsdorff and the brothers Johann Michael and Johann Christian Hoppenhaupt, used the palm tree as a framing device and as a connecting decora-

Individual pieces from Frederick II's first Potsdam dinner service, KPM, c. 1765–66

tive element. The king wanted palm trees instead of architraves for the theater in the Potsdam City Palace (1745), and for the ceiling of its Marble Hall (1746) he required lush palm crowns. In the 18th century, in addition to traditionally symbolizing authority (victory, majesty, divine world order) the palm stood for the exotic, unknown world.

For Frederick it was also emblematic of China, associated with the idea of a Voltaire's utopia ruled by enlightened, scholarly public officials, an appropriate interpretation for ceremonial halls. In the more private interior areas precedence was given to living requirements and taste.

Hence the palm decor in the Oval Cabinet of the New Palace is delicate, combined with painted iron bars and colorful flowering vines *à la chinoise*. This vaulted interior at the end of a suite of rooms leaves the impression of a "witty paraphrase of a pergola," to use Karl Foerster's words. It is the most elegant solution for an "espalier room" among all the possibilities that the Rococo had to offer.

Lemon Basket in Imitation of a Palm Tree with Summer and Winter Personified on a Plat de Ménage

Surtouts de table or *plats de ménage* are centerpieces of precious metal, faience or porcelain, rarely of bronze, used to display salt and sugar shakers, vinegar and oil bottles, mustard pots, as well as lemons. Sometimes they are even fitted with integrated candleholders. These condiments were used to season the food served and to adapt the taste at any given time according to individual taste.

Centerpieces were made fashionable by the court of Louis XIV. However, while terrines, platters and tureens, which in early modern times overloaded the dining table in the French manner and were cleared away completely after the first and second courses to make room for new dishes, the *plat de ménage* stood its ground in the middle of the table until the final dessert. It became even more popular at German courts in the 1820s and 1830s. Dresden played a leading role in its increasing popularity, impressing these courts with its glittering table culture. The first decorative *plats de ménage* were produced in the Meissen porcelain manufactory, and the lemon basket of the centerpiece exhibited here follows this style. For the Berlin porcelain manufacturers, the palm tree, with its crown of leaves towering above the condiments, offered an ideal shape on which to present citrus fruit. The *plat de ménage* now assumed the role of a regal ornamental dessert table, transforming it into a garden of sugary porcelain.

Michaela Völkel

Plat de ménage centerpiece in imitation of a palm tree crowned by a lemon basket, decorated with allegorical figurines personifying summer and winter, Berlin, KPM and Gotzkowsky (*Personification of Summer*), c. 1763

Design for the Ceiling in the Concert Room at Sanssouci Palace

Johann August Nahl brought to paper his ideas for the design of the ceiling in Frederick II's Concert Room in his draftsman's light, elegant and simultaneously expert hand. This highly imaginative and dainty design shows an airy trellis work, entwined with grapevines, which – freed of any weightiness – creates the illusion of a treillage pavilion in an outdoor garden space.

Transparent pillars made of latticework rise from the corners, atop which are set tall, slim obelisks, entwined by vine shoots. Latticework arches at their sides are connected by two reversed rocailles, from which a basket filled with grapes hangs. In contrast, the room's longitudinal sides are accentuated by vases, in each of which a thyrsus or staff of Bacchus rises up and is also intertwined by wine leaves. A finely-meshed spider web is spread above the tips of the obelisks and the leaf tendrils. It forms the center of the ceiling, which seems to open itself both to nature and to the light.

The hunting scenes with depictions of putti and animals are missing in the design, but would ultimately come to life on the stucco ceiling, carried out in white and gold. The hunting nets alone appear to have been hinted at in advance.

Johann August Nahl was appointed "Directeur des Ornements" in 1745. However, he hastily left Prussia in July 1746 because of overwork and other dissonance. His designs for the palaces in Potsdam are among the artistic highlights of the Frederician and European Rococo.

Claudia Sommer

Johann August Nahl the Elder, *Design for the ceiling in the Concert
Room at Sanssouci Palace*, 1745–46

The Dream of Eternal Spring: The Fragrant Magic of Flowers Made of Porcelain and Silk

Käthe Klappenbach

Through the ages, the evanescent beauty of nature in bloom has inspired artists to create objects from the most diverse materials. This fashion celebrated its apogee in the second half of the 18th century. Known as the Rococo period, its name is derived from the French "rocaille" (ornamentation using shells and pebbles), an indication of the type of design it embraced. The art of "imiter la nature," enjoyment of imitating nature to perfection, originated in early 18th century Paris, and was strongly influenced by Madame de Pompadour's love for all things that expressed the beauty of nature. This style is reflected in all the luxury items she developed closely with leading French craftsmen. Spring was "preserved" in "exquisite, factitious gardens made of porcelain, silk, canvas, paper, feathers." (Camporesi 1992, p. 124) These chimerical decorations spread throughout the European royal houses, which they both pleased and represented. These "eternal" blooms also symbolized the immortality of the respective dynasty.

This style is already apparent in the decoration and furnishing of Crown Prince Frederick's rooms in Rheinsberg Palace, the design of young King Frederick II's living quarters in Charlottenburg Palace, and the City Palace in Potsdam, which evolved further at Sanssouci Palace and reached its consummation in the New Palace. An abundance of decorative flowers in such a variety of shapes and materials set this royal edifice apart from all other royal Frederician palaces.

Wall decorations imitated pergolas or grottos. One example of this kind were decorations known in Prussia as "Branchen," gold or

Chandelier with eight candles designed to look like a flower-clad pergola, Paris and Vincennes, c. 1750

silver-plated bronze tree branches with leaves, blossoms and candle sleeves that were attached to wall plates. The flowers climbing up the sumptuous silk wall coverings, as if coiled around an invisible trellis, had an even more convincing effect. Motifs from nature were also seized upon and incorporated in the furniture design, whether as colorfully designed inlays shaped from a range of natural materials, or fire-gilded imitations of flowers and leaves on the bronze fittings.

Porcelain proved ideal for imitating nature, especially different flowers. Based on the Meissen and Vincennes designs, where naturalistic flowers made of porcelain had been produced since 1747, the

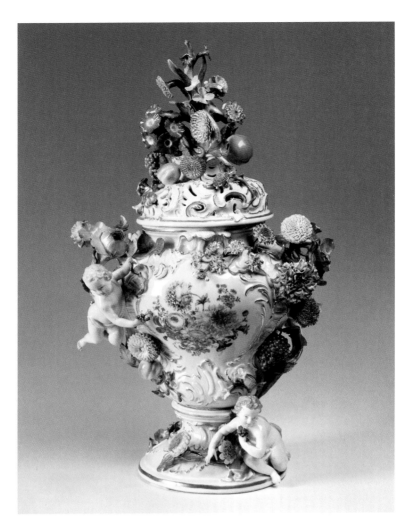

Potpourri vase, Meissen, 1760

Königliche Porzellan-Manufaktur (KPM) in Berlin began in 1765 to create delightful blossoms that were perfect replicas of living flowers, and that were ideal for decorating a variety of luxury goods. Their appearance was so deceptive that one could almost smell their scent. Particularly ingenious designs came to fruition when these blossoming branches decorated objects used for lighting, such as sconces, candelabras and chandeliers, the expensively flickering candlelight "playing" upon the floral embellishments. This type of lighting also framed the decorations of a royal dining table in a special light, mir-

roring the theme of a room with ornate centerpieces resembling a garden "en miniature." Dishes were served in true-to-life objects made of porcelain or silver, such as boxes, bowls, tureens and cloches in the shape of grapefruits, bundles of asparagus, whole cabbages or vine leaves.

This seduction of the senses emanated from the floral scent of Rococo, which was as delicate as its colors. It was intended to preserve the fragrance of spring and summer during the darker months of the year. Numerous recipes for perfumes from that time, so-called *potpourris,* as well as aromatic essences survive. Porcelain receptacles decorated with flowers – also called potpourri – with perforated covers were used for these flower, fruit and spice mixtures. Oil burners, *brûle parfums*, were used as room scents. It was these fragrances and particular designs, with their seemingly authentic flowers that feigned a lack of guile, which produced this sensory deception so typical of that time; a particular kind of magic by which we might just as easily be carried away!

Silk Wall Coverings with Floral Vines

Chrysanthemums and peonies wind their way up the walls in big sweeping gestures, as if coiled around an invisible trellis. The smooth, silky background gives the brocaded flowers a particularly vivid appearance. The animated leaves and flowers are deceptively natural. However, chrysanthemums, which originally came from China, were not yet widespread in the gardens of 18th century Europe; with their long-term cultivation in Europe first beginning in 1789. Shrub peonies, which also came from China, only found their way into European gardens in the 19th century. In 18th century Prussia these exotic blossoms were probably only known from drawings and decorations on porcelain.

Thus exotic Chinese style flowers and tendrils wound their way into the royal bedrooms at the New Palace, transformed into silk, an evanescent natural material. The style and shapes of the chrysanthemum and peony tendrils gracing the walls pick up the theme of the inlaid flowers of the corner Cabinet designed by Heinrich Wilhelm Spindler, which was built for this bedchamber.

The design of the silk hangings is also reflected in the undulating, flowering vines of the stucco ceiling, as well as the intertwined plants depicted on the area rugs produced in the manufactory of Charles Vigne. However, this indoor space is not the replica of an actual garden, but rather integrates an ideal world of plants into the decorative scheme of Frederician interior decoration.

Susanne Evers

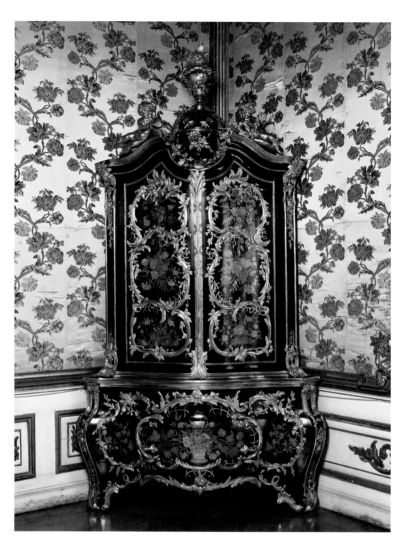

Brocaded atlas silk wall covering, Large Bedchamber in the
Lower Royal Suite (New Palace), woven in Berlin c. 1765, with a
corner cabinet by Heinrich Wilhelm Spindler, Potsdam, 1768

Luminescent Luxury

Since the mid-18th century, sconces were listed as "Branchen" (the French for branch or twig is "branche") in Prussian palace inventories. They were fashioned to look like branches in bloom, with candle sleeves attached, made of brass and fire-gilded in gold or silver, and were always fitted next to fireplace or window mirrors to reflect the light as effectively as possible.

They were mainly part of the wall decoration, hence their design varied according to the function and importance of the room. Candles were only lit for important occasions, as they were expensive, especially when compared to the other pieces of art in the room. Prototypes were obtained from France as designs, or were purchased from manufacturers from Paris, who began to settle in Potsdam and Berlin after 1751. There were at least 700 of these kinds of sconces in Prussian palaces, which was without precedent in Europe at that time. Today, about 500 original pieces survive.

Of particular interest are the few sconces acquired in Paris, decorated with colored leaves and porcelain flowers from Vincennes, which resemble bushes blossoming from the walls, of which a certain type can be seen at Sanssouci and another at the New Palace. The lighting at the New Palace exactly resembles that owned by Madame de Pompadour, which she almost certainly obtained from her luxury goods supplier, Lazare Duvaux, the "marchand bijoutier ordinaire du Roi."

It was this kind of lighting, made of bronze and colorful flowers, that allowed Madame de Pompadour to transform the interiors into

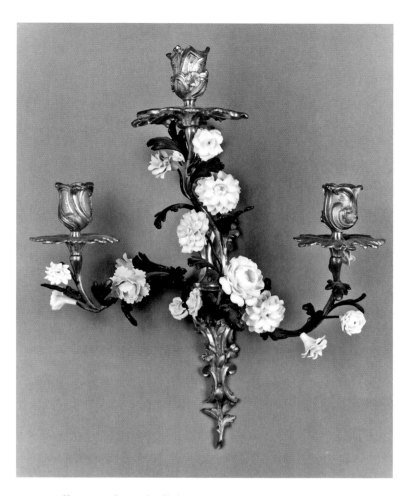

Wall sconce from the living room in the Apartment of Prince Henry at the New Palace, from the workshop of Lazare Duvaux (Paris) and Porcelain Manufactory Vincennes, c. 1749

"eternal spring." Tradition has it that she even perfumed the porcelain blossoms.

Although there is no absolute proof, it can be assumed with some certainty that Frederick II acquired various works of art of this type from the estate of Madame de Pompadour, who had died in 1764.

Käthe Klappenbach and Ulrike Milde

"The Magical Powers of Painting and Perspective ..." – The Landscaped Interior around 1800

Sabine Jagodzinski and Matthias Gärtner

The rediscovery of the variety and colorfulness of the ancient world at the Italian excavation sites at Pompeii and Herculaneum (around 1760) and expeditions to remote, unknown regions of the world whose findings were circulated in travelogues and engravings led to an idealization of other times and faraway places in the 18th century, and ultimately to a new conception of human existence. Humanity, which was equated with human dignity and tolerance towards other attitudes, replaced pure demonstrations of power. Fashion was able to cloak itself in various stylistic forms, because of the dissolution of a Baroque canon of presentation. This breakdown of the barriers between outdoor forms and interior design finds expression in the Palm Hall, which Frederick William II had constructed inside the Orangery in the New Garden (1791). The painted columns hung with luxuriantly planted vases mimicking antiquity, Neoclassical arabesques on the ceiling, and stylized palms on the walls enhanced this effect. The large southern windows act as a bridge, or transition into the garden. During celebrations the plant halls were lit up by cleverly arranged, exotic oil lamps in the shape of the rare pineapple, which was being cultivated in Potsdam with a great deal of effort. "Otaheite" (Tahiti), the island discovered in 1767, provided the name for a "new Arcadia." It was intended to symbolize the lost paradise, as an expression of the untouched natural state of human beings and nature. The South Seas appeared to be a living example of Rousseau's philosophy of nature, a new Cythera (island of Aphrodite), in which the unspoiled, free human being might be found. A key work asserting this new out-

Carl Gotthard Langhans, *Orangery in the New Garden*, wall design for the Palm Hall and drawings for vase forms, 1791

look was the sentimental novel *Paul et Virginie* (1788) by Jacques Henri Bernardin de Saint-Pierre. He upheld idyllic, paradisiacal love, freed from both state and civilization. Inspired by these notions, Frederick William II and his mistress Wilhelmine Encke (Countess Lichtenau) had a South Seas paradise brought to Prussia, manifested in the round Otaheitische Kabinett (Tahitian Chamber, 1797) at the small palace on Peacock Island. The floor is laid out with local woods as a cross-section of a palm tree. Fictitious landscape views onto Peacock

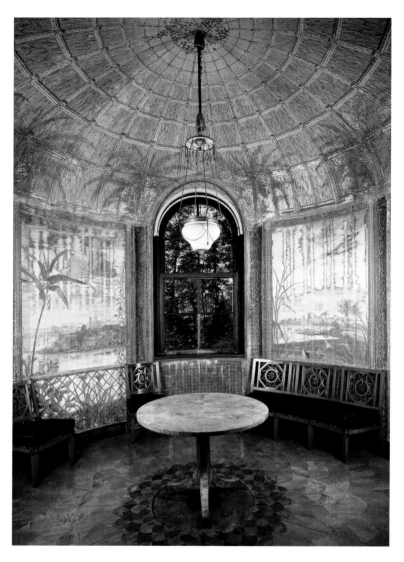

Berlin, Palace on Peacock Island, Tahitian Chamber

Island's surroundings, now tropically defamiliarized with painted prickly pears and pineapple shrubs, evoke the illusion of a sheltering bamboo hut on an island of love.

Idealistic aspirations towards a new civilization – of living in harmony with nature that is still intact – led to an abundant European production of illusionistically painted wallpaper featuring Arcadian landscapes. Here, too, antiquity and exoticism coexisted,

as for example at the simple country palace in Paretz, which David Gilly built for Frederick William III and his wife Luise from 1797–1804. Flowering trees and shrubs scale the walls in the Garden Hall, while fruit springs from their leaves, and palms grow into the sky – on paper. Everything gives the impression of a spacious, luxuriant garden. The unique wallpapers from the Paretz Palace with their illusionist effects remain fascinating evidence of the longing for nature around 1800. They were manufactured in Berlin and can be admired in the exhibition in Hellmuth Unger's watercolors.

The Garden Hall in the Stables at Paretz Palace

The oval Garden Hall, formerly situated in the main section of the royal stables, housed one of the most beautiful examples of painted natural illusions in interiors around 1800. What special magic must this room have emanated? Its walls, pasted with paper, were completely covered from floor to (mirrored) ceiling with an image of a tropical landscape, painted with palms and exotic trees, as well as all sorts of colorful birds. Staged neither with organizing or subdividing frames, nor as a fictitious view from the inside to the outside – as, for instance, in the "Otaheitischen Kabinett" (Tahitian Chamber) on Peacock Island – the interior decoration of the Garden Hall evokes a nearly perfect illusion of being surrounded by nature; as if one were sitting or moving within a foreign, exotic world, on a faraway, paradisiacal island ("Otaheite" is another name for Tahiti). Rock formations were painted in the four niches. In one of them – not visible in the watercolor – a large clay sculpture of a Chinese man holding a parasol was a heating element that sat atop a stove. However, we can see that the concept of a distant exotic paradise relied more on fantasy than on fact. The interior decoration was carried out by Johann Wilhelm Niedlich, a Berlin-born decorator and wallpaper painter.

The Garden Hall was destroyed in 1948 along with the demolition of the stables. Today, only Hellmuth Unger's watercolor painting still conveys a vague idea of the formerly colorful effect of this extraordinary landscaped room.

Claudia Sommer

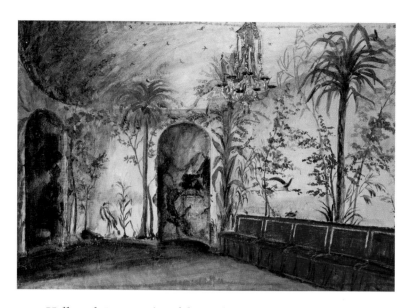

Hellmuth Unger, *View of the Garden Hall in the Stables at Paretz Palace*, 1922

Pineapple Lamp from the Orangery in the New Garden

Tin-plated and wire-reinforced iron, painted green; glass cylinder, silk lantern (1988 replica, made from painted, artificial silk).

The cultivation of pineapple plants in Brandenburg-Prussia began sometime in the mid-18th century. However, real success with the complicated and difficult cultivation of this exotic fruit was not obtained until the end of the century. Thereafter, the extremely tasty royal fruit was also grown on a grand scale in Potsdam. It was a symbol of prosperity and an exclusive lifestyle. Its consumption was a pleasure reserved only for a select, very wealthy group of people.

In the Frederician period the pineapple began to be included in designs of works of art as a sign of appreciation for the great efforts of the pineapple gardeners. The fruit, for instance, crowns the famous chandeliers of the Königliche Porzellan-Manufaktur Berlin (KPM) and was used as the terminating decorative element of a fire-gilt bronze chandelier in the Chinese House.

In the plant halls of the Orangery in the New Garden, lanterns imitating pineapples, made of painted metal and exquisitely painted silk, truly baffled the eye. White flower pots standing on consoles spread along the walls held the 22 original lanterns, of which 18 still survive. Oil lamps in glass cylinders positioned behind them provided the light. This naturalistic design created the impression of real fruit, which certainty provided for a most unusual illumination and festive atmosphere in the plant halls.

Käthe Klappenbach

Pineapple lamp, Berlin or Potsdam, c. 1792, (original silk shade now a synthetic replacement made in 1988), silk lantern (replica, made of painted, artificial silk, 1988).

Retreating to the Garden Room

Silke Kiesant

The confluence of gardening and architecture during the Bieder-meier era (c. 1815-48) brought forth a change in design. Conservato-ries (such as the Palm House on Peacock Island) created the illusion of an elemental, exterior world that had been transposed indoors. A por-tico and pergola (like those at Charlottenhof Palace) often led from a room or salon outdoors into nature, abounding with terraces contain-ing artfully decorated flowerbeds edged with gilded borders, mosaic garden paths, flower fountains, and sculptural adornments and gar-den furniture, which could be arranged according to individual fancy as seen at Babelsberg Palace). Drawing rooms and parlors expanded into the outdoors, creating cozily secluded seating areas under vine-clad pergolas, as exemplified in the Sicilian Garden, the Rose Garden at Charlottenhof Palace, or the Large Pergola at the Roman Baths.

Hence, a new and more private domesticity evolved from this style of interior design. Living quarters became safe havens in which to retreat, where family life could unfold in a more casual atmos-phere, enabling the pursuit of individual interests without forego-ing the delights of nature and the outdoors. A new decorative aes-thetic evolved, giving rise to new shapes in furniture, such as sewing tables, *jardinières* (flower tables and boxes), and a wide range of dif-ferent types of seating that could be grouped into small living spaces. Karl Friedrich Schinkel's concept of transplanting exterior space into interior spaces was enacted in numerous Prussian palaces: the Exe-dra (a semicircular outdoor bench), inspired by a Pompeiian funerary chamber from the 1st century (the so-called Schola Tomb of Mamia)

Unknown artist, *Large Pergola Near the Roman Baths*, c. 1835

became a prominent design element, to be found in garden-like interiors decorated with leafy plants (e.g. Frederick William IV's Tea Salon in the Berlin Palace).

The Biedermeier era also brought with it a flood of small decorative objects arranged on *étagères* (also known as "what-nots") and side tables: albums, mementos, painted porcelain cups and birds, as well as beetle and butterfly collections in display cases, and stuffed birds. As opposed to previous eras, living plants, birds and the occasional ornamental fish found their way indoors, as witnessed by the sheer volume of inventoried bird cages and parrot perches. At Charlottenhof Palace an aviary was built within the portico, merging the interior with the exterior.

The proliferation of indoor greenery at that time can be seen in many images of indoor scenes, which offer a glimpse into these "Gartenzimmer" (garden interiors) with their brightly colored decorations. Carpets imitating colorfully flowering meadows, and wallpaper, curtains and other furnishing materials draped with large blossoms were combined with towering palm trees and artful flower compositions arranged by the gardeners. Flower tables with metal insets for plants in tubs, and lattices with ivy tendrils, which could also be used as birdcages, as well as sculptures and portraits entwined with plants reflected this yearning for nature and a sentimental, keepsake

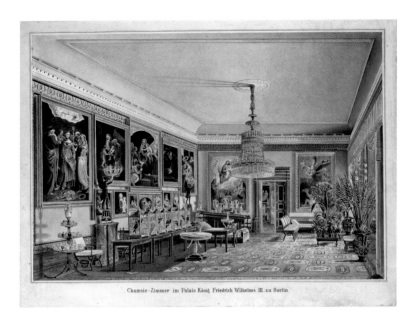

Chamois-Zimmer im Palais König Friedrich Wilhelms III. zu Berlin

Friedrich Wilhelm Klose, *The Chamois Room in Frederick William III of Prussia's Kronprinzenpalais in Berlin*, c. 1840

culture. A passion for flowers resulted regularly in outright competitions among the "florists," focusing on the most magnificent and fragrant specimens of the newest breeds. Publications of that time, such as the *Journal des Luxus und der Moden*, describe the "art of indoor gardening" as being particularly popular among the ladies, as the combined effect of the flowers' scent and decorative appearance pleased their delicate senses twice as much. Readers were also advised against keeping strongly scented plants indoors. Honeysuckle and orange blossoms, marigold, white lilies and daffodils kept in badly ventilated rooms were considered to occasionally cause dizziness and fainting in people with "delicate nerves."

Crown Princess Elisabeth's Living Room at the Berlin Palace

In the first half of the 19th century, small-scale "Zimmerbilder" (i.e. room pictures or interior scenes predominantly painted in water-color) were an exceedingly popular genre in great demand at the European courts, as well as in respectable middle-class homes. A number of portraits in this style have survived of Crown Princess and later Queen Elisabeth of Prussia's living room at the Berlin Palace. Spanning a ten-year period, they attest to changes that began in 1830 showing how living plants were used indoors. More robust and abundant presentations of hardier leafy plants gradually supplanted individual, perishable cut flower arrangements in vases. Potted plants conquered indoor spaces, insinuating themselves into the royal apartments. This development was facilitated by the introduction of new types of plants, successfully cultivated and better suited to "Zimmergärtnerei" (indoor gardening).

This watercolor depicts three different plant designs. The crown princess' desk to the left looks as if it has been placed in a pergola. Next to the legs of the desk, an ivy growing in a tub coils around a high-arched wire construction resembling a trellis. Between them, to add color and perhaps as an olfactory contrast to the green-leafed plants, there is a *jardiniére*, a table with an inset basin made of tin containing roses in bloom and a calla plant. Elisabeth had the marble likeness of her husband Crown Prince Frederick William (IV) as a young man placed before a towering arrangement of plants. To the right in the picture, there is a large birdcage, which according to the description in the inventory was made of "mahogany and brass wire, crowned by an insert of green-painted tin culminating in flowers."

Claudia Sommer

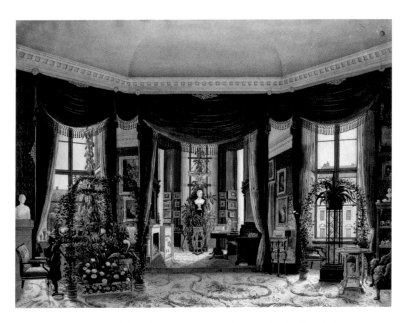

Johann Heinrich Hintze, *Crown Princess Elisabeth's Living Room at the Berlin Palace, View of the Bay Window*, 1838

The Parrot from Queen Elisabeth's Living Room at Charlottenhof Palace

Inspired by explorers' reports of their expeditions, it became increasingly fashionable during the first half of the 19th century to decorate private residences with canaries, parakeets or parrots, as well as living plants. The birds created an aura of vibrant, colorful nature and were also a symbol of considerable luxury. Their birdsong, their docility and their ability to imitate human sounds made them popular companions. Some of them even became the object of royal correspondence. Queen Elisabeth of Prussia often spoke about her beloved "feathered Lorchen" (died in 1853), with whom she "conversed," and who was allowed to climb on the curtains and to come onto her bed. The bird even accompanied her on journeys, where it caused a sensation among the children of the court in Dresden, for instance. Whether or not this pet was the same parrot represented here is not known. This stuffed bird found its home under a glass cover in Elisabeth's living room at Charlottenhof Palace beginning sometime around the mid-19th century. It may also have previously belonged to her father-in-law, King Frederick William III. Seven large brass cages housing a total of eight parrots stood on four tables in the Chamois Room at his palace in Berlin. After his death (1840) the precious birds were passed down to female members of the royal family, with one of the parrots going to Elisabeth. In his *Naturgeschichte der Stubenvögel* (Natural History of Cage Birds, 1795), Johann Matthäus Bechstein provided an impression of the background noise in rooms animated by the sounds of birds. Speaking about the rose-ringed parakeet, for example, he noted: "It is noisy and shouts constantly; it learns to

Parrot, mid-19th century, preserved specimen mounted on a branch

speak, to whistle and to imitate the voices of most animals and birds very easily. When locked in a cage, in which it has little room to move, it talks and squawks incessantly, so that it often becomes insufferable."

Silke Kiesant

Select Bibliography

ALGAROTTI, FRANCESCO. *Versuche über die Architektur, Mahlerey und musicalische Opera.* Kassel: 1769

ARNDT, HELLA. "Gartenzimmer des 18. Jahrhunderts," In *Wohnkunst und Hausrat*, Vol. 42. Darmstadt: 1964.

ARTELT, PAUL. *Die Wasserkünste von Sanssouci. Eine geschichtliche Entwicklung von der Zeit Friedrichs des Großen bis zur Gegenwart.* Berlin: 1893.

BECHSTEIN, JOHANN MATTHÄUS. *Naturgeschichte der Stubenvögel oder Anleitung zur Kenntniß und Wartung derjenigen Vögel, welche man in der Stube halten kann.* Gotha: 1795.

BELANI, H. E. R. [Carl Ludwig Häberlin]. *Geschichte und Beschreibung der Fontainen von Sanssouci.* Unchanged photomechanical copy of the original edition from 1843. Potsdam: Generaldirektion der Staatlichen Schlösser und Gärten Potsdam-Sanssouci, 1981.

BELANI, H. E. R. [Carl Ludwig Häberlin]. *Sanssouci, Potsdam und Umgebung: mit besonderer Rücksicht auf die Regierungszeit Friedrich Wilhelm IV.* Berlin: 1855.

BERNARDIN DE SAINT PIERRE, JACQUES HENRI. *Paul und Virginie und Die Indische Hütte.* New edition by G. Fink. Pforzheim: 1840.

BEYLIER, HUBERT. *Treillages de Jardin du 14ème au 20ème siecle, Centre de Recherches sur les Monuments Historiques.* Wittenheim: 1993.

BLONDEL, JAQUES FRANCOIS. *De la distribution des maisons de plaisance et de la décoration des édifices en général,* Vol. 2. Paris: 1738.

BÖRSCH-SUPAN, EVA. *Garten-, Landschafts- und Paradiesmotive im Innenraum. Eine ikonographische Untersuchung.* Berlin: 1967.

BÖRSCH-SUPAN, HELMUT. *Marmorsaal und Blaues Zimmer. So wohnten Fürsten.* Berlin: 1976.

BURSCHE, STEFAN. *Tafelzier des Barock.* Munich: 1974.

BUTTLAR, ADRIAN VON AND MARCUS KÖHLER. *Tod, Glück und Ruhm in Sanssouci. Ein Führer durch die Gartenwelt Friedrichs des Großen.* Ostfildern: Stiftung Preußische Schlösser und Gärten Berlin-Brandenburg, 2012.

CAMPORESI, PIERO. *Der feine Geschmack. Luxus und Moden im 18. Jahrhundert.* Frankfurt am Main: 1992.

DIDEROT, DENIS/D'ALEMBERT, and JEAN-BAPTISTE LE ROND. *Encyclopédie, ou dictionnaire raisonné des sciences, des arts et des métiers,* Paris, Amsterdam, Livorno: 1751–1781.

DORGERLOH, ANNETTE. "Kornblumen und Königin Luise: Pflanzensymbolik im Erinnerungskult." In *Schön und nützlich. Aus Brandenburgs Kloster-, Schloss- und Küchengärten*, Berlin: Haus der brandenburgisch-preußischen Geschichte. 2004, 193–203.

DUVAUX, LAZARE. *Livre-Journal de Lazare Duvaux, Marchand Bijoutier ordinaire du Roi 1748–1758.* Louis Courajod, ed. Paris: 1873.

EGGELING, TILO. *Raum und Ornament, Georg Wenzeslaus von Knobelsdorff und das friderizianische Rokoko,* 2nd edition. Regensburg: 2003.

EVERS, SUSANNE. *Seiden in den preußischen Schlössern. Ausstattungstextilien und Posamente unter Friedrich II. (1740–1786).* With assistance from Christa Zitzmann. Berlin: Generaldirektion der Stiftung Preußische Schlösser und Gärten Berlin-Brandenburg (Inventory catalogues from the collections of applied arts: textiles). 2014.

FOERSTER, CARL FRIEDRICH. *Das Neue Palais bei Potsdam. Amtlicher Führer.* Berlin: 1923.

FORSTER, GEORG. *Reise um die Welt während den Jahren 1772 bis 1775,* 2 vols. Berlin: 1778–80.

Friedrich Wilhelm II. und die Künste. Preußens Weg zum Klassizismus. Exh. cat. Potsdam: Stiftung Preußische Schlösser und Gärten Berlin-Brandenburg, 1997.

"Goldorangen, Lorbeer, Palmen – Orangeriekultur vom 16. bis 19. Jahrhundert," Festschrift for Heinrich Hamann. Petersberg: *Schriftenreihe des Arbeitskreises Orangerien in Deutschland e.V. 6/2010,* 2010.

GRÖSCHEL, CLAUDIA. "Großer Herren Vergnügen – Orangeriepflanzen in Kunst und Kunsthandwerk." In *Wo die Zitronen blühen. Orangerien, historische Arbeitsgeräte, Kunst und Kunsthandwerk,* Exh. cat. Potsdam: Stiftung Preußische Schlösser und Gärten Berlin-Brandenburg, 2001.

HIRSCHFELD, CHRISTIAN CAY LORENZ. *Theorie der Gartenkunst,* Vol. 1. Leipzig: 1779.

HOHBERG, WOLF HELMHARDT VON. *Georgica curiosa.* Nuremberg: 1716.

HOLLENDER, SILKE, *Schloss Charlottenhof und Römische Bäder. Ein italienischer Traum.* With assistance from Antje Adler. Munich: 2003.

HOSKINS, LESLEY, ed. *Die Kunst der Tapete. Geschichte, Formen, Techniken.* Stuttgart: 1994.

KASCHUBE, ADOLF. "Das Grabensystem des Parks Sanssouci und seine Veränderungen." In *Mitteilungen der Studiengemeinschaft Sanssouci e. V.,* 2/2004. 2–23.

KRAUSCH, HEINZ-DIETER. *Kaiserkron und Päonien rot – Von der Entdeckung und Einführung unserer Gartenblumen,* Munich, 2007.

KURTH, WILLY. *Sanssouci, Ein Beitrag zur Kunst des Deutschen Rokoko.* Berlin: 1962.

LAUTERBACH, IRIS. "Der Garten im Innenraum und in der Malerei." In *Gartenkunst in Deutschland. Von der Frühen Neuzeit bis zur Gegenwart. Geschichte – Themen – Perspektiven.* Stefan Schweizer and Sascha Wiener, eds. Regensburg: 2012, 449–465.

LAUTERBACH, IRIS. "Gartenkunst." In *Interieurs der Goethezeit. Klassizismus, Empire, Biedermeier.* Christoph Hölz, ed. Augsburg: 1999, 178–210.

MANGER, HEINRICH LUDWIG. *Baugeschichte von Potsdam, besonders unter der Regierung König Friedrich des Zweiten.* Reprint of original from 1789–90 in 3 vols. Leipzig: 1987.

MARPURGER, PAUL JACOB. *Vollständiges Küchen- und Keller-Dictionarium.* Hamburg: 1716.

MOSER, FRIEDRICH KARL VON. *Teutsches Hofrecht.* Frankfurt am Main, Leipzig: 1761.

MÜLLER, HELLA. *Natur-Illusion in der Innenraumkunst des späteren 18. Jahrhunderts.* Hanover: 1957.

NIETNER, THEODOR. "Der Rosengarten beim Neuen Palais zu Potsdam." In *Die Rose.* Berlin: 1880, 151–154.

OTTOMEYER, HANS, KLAUS ALBRECHT SCHRÖDER, LAURIE WINTERS, eds. *Biedermeier. Die Erfindung der Einfachheit.* Exh. cat. Milwaukee Art Museum, Milwaukee; Albertina, Vienna; Deutsches Historisches Museum, Berlin; Louvre, Paris. Ostfildern: 2006.

PAŠCINSKAJA, IRINA. "Festliche Illuminationen im Unteren Garten von Peterhof in der ersten Hälfte des 19. Jahrhunderts." In *Die Gartenkunst,* 1/2013, 181–204.

SCHÖNEMANN, HEINZ. "Charlottenhof – Schinkel, Lenné und der Kronprinz." In *Potsdamer Schlösser und Gärten. Bau- und Gartenkunst vom 17. bis 20. Jahrhundert.* Pots-

dam: Generaldirektion der Stiftung Schlösser und Gärten Potsdam-Sanssouci, 1993, 173–181.

SCHURIG, GERD. "Ananas – eine königliche Frucht." In *Schön und nützlich. Aus Brandenburgs Kloster-, Schloss- und Küchengärten.* Potsdam: Haus der brandenburgisch-preußischen Geschichte, 2004, 162–165.

THÜMMLER, SABINE. "Der ewige Garten – Landschafts- und Gartenzimmer als Ideal." In *Gartenfeste. Das Fest im Garten – Gartenmotive im Fest.* Exh. cat. Museum Huelsmann. Bielefeld: Hildegard Wiewelhove, 2000, 127–135.

"Ueber den Luxus der Zimmer-Gärten." In *Journal des Luxus und der Moden*, Vol. 7, December 1792, 597–605.

WACKER, JÖRG. "Der Einfluss der Kronprinzessin Victoria auf die Gärten vor dem Neuen Palais." In *Auf den Spuren von Kronprinzessin Victoria – Kaiserin Friedrich (1840–1901).* Potsdam: Stiftung Preußische Schlösser und Gärten Berlin-Brandenburg, 2001, 33–41.

WAGENER, HEINRICH. "Die Kronprinzlichen Anlagen beim Neuen Palais im Parke von Sanssouci." In *Der Bär*, 7/1881, 389–394.

WAPPENSCHMIDT, FRIEDERIKE. *Der Traum von Arkadien.* Munich: 1990.

WAPPENSCHMIDT, FRIEDERIKE. "Friedrich der Große und die preußische Luxuswarenindustrie." In *Weltkunst*, 17/1988, 2390–2394.

WAPPENSCHMIDT, FRIEDERIKE. "Inspiration durch Konkurrenz. Blumen aus der Porzellanmanufaktur in Vincennes." In *Weltkunst*, 21/1997, 2334–2335.

WAPPENSCHMIDT, FRIEDERIKE. "Madame Pompadour und die Kunst. 1: Die Regentin des *Empire de lux.*" In *Weltkunst* 11/1989, 1618–1621.

WAPPENSCHMIDT, FRIEDERIKE. "Madame Pompadour und die Kunst. 2: Die *belle alliance* mit dem Kunsthändler Lazare Duvaux." In *Weltkunst*, 12/1989, 1774–1777.

WIMMER, CLEMENS ALEXANDER. "Kaiserin Friedrich und die Gartenkunst." In *Mitteilungen der Studiengemeinschaft Sanssouci e. V.*, 2/1998, 3–27.

WINCKELMANN, JOHANN JUST. *Ammergauische Frühlingslust.* Oldenburg: 1656.

WITTWER, SAMUEL. "Blütenduft für Preußens feine Nasen. Potpourris im Neuen Palais." In *Schön und nützlich. Aus Brandenburgs Kloster-, Schloss- und Küchengärten.* Potsdam: Haus der brandenburgisch-preußischen Geschichte, 2004, 147–150.

Sources

GStA PK (Geheimstaatsarchiv Preußische Kulturbesitz), BPH Repro. Services, 50 T, No. 54, Vol. 9, 1847–1850 and Vol. 10, 1851 (correspondence from Queen Elisabeth of Prussia).

SPSG (Stiftung Preußische Schlösser und Gärten Berlin-Brandenburg), Hist. Inventory, No. 231: Itemized list of the royal summer residence, Charlottenhof Palace, Vol. I., 1847.

SPSG, Hist. Inventory, No. 766: List of all non-inventoried objects in the palace at the time of the king's death [after 1840].

Photographic Credits

Stiftung Preußische Schlösser und Gärten Berlin-Brandenburg (SPSG), pp. 26, 28, 29, 31, 41, 59, 65, 74, 79 (2), 83, 87, 91, 92, 103, 104, 106, 112, 121, 126, 131, 141, 145, 149, 150, 152; photographers: Jörg P. Anders, pp. 62, 118 / Hans Bach, pp. 8, 10, 16, 18, 24, 30, 36, 37, 67, 93 / Roland Handrick, pp. 14, 77, 89, 94, 147 / Daniel Lindner, pp. 56, 57, 72, 82, 134 / Gerhard Murza, pp. 38, 116 / Wolfgang Pfauder, pp. 13, 68, 97, 117, 124, 127, 137, 139, 142, 154 / Hans-Jörg Ranz, pp. 133 / Luise Schenker, p. 129 / Leo Seidel, pp. 54, 120

Photographs (by the authors and other contributors): Marina Heilmeyer, pp. 34, 40 / A. Herrmann, pp. 47, 49 / F. Hoehl, pp. 48, 51 / N. A. Klöhn, p. 50 / Kathrin Lange, pp. 70, 71 / Moritz von der Lippe, p. 44 / Tim Peschel, pp. 109, 110 / Gesa Pölert, pp. 85 / Michael Rohde, p. 64 / Gerd Schurig, pp. 76, 97, 113 / Michael Seiler, p. 107

SPSG, KPM-Archiv, p. 43

Staatliche Museen Berlin (SMB-PK), Kupferstichkabinett, p. 59

Universitätsbibliothek Heidelberg, p. 100 (2)

Zentralinstitut für Kunstgeschichte, Munich, p. 96

Cover: SPSG, Pond at the Villa Illaire, photo: Hans Bach (2011)

Back cover illustration: SPSG, Sanssouci Palace with spring garden arrangements, photo: Leo Seidel (2013)

Imprint

Publication accompanying the open-air exhibition "Paradiesapfell – Park Sanssouci" from April 18 – October 31, 2014, Potsdam, Sanssouci Park.

Publisher: The General Direction of the Stiftung Preußische Schlösser und Gärten Berlin-Brandenburg (SPSG)

Project Manager: Heike Borggreve

Editing: Ulrich Henze

Image Editing: Silke Cüsters

English translations: James Bell, Cressida Joyce, Wendy Wallis

Editing: Gabriela Wachter, Deutscher Kunstverlag

Reproductions: Birgit Gric, Deutscher Kunstverlag

Printing and Binding: AZ Druck und Datentechnik GmbH, Berlin

Bibliographical information of the Deutsche Nationalbibliothek (German National Library). The Deutsche Nationalbibliothek lists this publication in the Deutsche Nationalbibliografie; detailed bibliographic data are available on the Internet: http://dnb.dnb.de.

Supported by the Beauftragte der Bundesregierung für Kultur und Medien through a resolution of the German Bundestag

(c) 2014 Stiftung Preußische Schlösser und Gärten Berlin-Brandenburg and the authors

(c) 2014 Deutscher Kunstverlag GmbH Berlin München

Paul-Lincke-Ufer 34

D-10999 Berlin

www.deutscherkunstverlag.de

ISBN 978-3-422-07268-8

Visitor Services

Sanssouci Park
D-14469 Potsdam

Contact
Stiftung Preußische Schlösser und Gärten Berlin-Brandenburg
Mailing address: Postfach 601462, D-14414 Potsdam
www.spsg.de

Visitor Information
e-mail: info@spsg.de
Telephone: +49 (0) 331.96 94-200

Group Services
e-mail: gruppenservice@spsg.de
Telephone: +49 (0) 331.96 94-222
Fax: +49 (0) 331.96 94-107

Visitor Center at the Historic Windmill
An der Orangerie 1, D-14469 Potsdam
Opening hours:
April–October, 8:30–5:30
Closed Mondays

Visitor Center at the New Palace
Am Neuen Palais 3, D-14469 Potsdam
Opening hours:
April–October, 9–6
Closed Tuesdays

Potsdam Tourism Services
Tel.: +49 (0)331 27 55 850
http://www.potsdamtourismus.de

Legend

1. The Colonnade at the New Palace
2. The Frederician Hedge Theater
3. The Imperial Rose Garden at the New Palace
4. 5. The Marble Sculptures in the Parterre at the New Palace
6. The Parkgraben
7. The "Theaterweg" in Charlottenhof Park
8. The Importance and Care of Groups of Trees
9. The Water Displays at Charlottenhof
10. The Rose Garden at Charlottenhof
11. Long-Grass Meadows as Biotopes
12. A Piece of Italian Culture
13. Special Exhibition at the Roman Bath, in 2014:
 "From Flowered Chambers and Landscaped Interiors:
 The Garden in the Interior, 1740–1860"
14. Fruit Cultivation at Sanssouci
15. The Eastern Pleasure Ground
16. The Neptune Grotto
17. The Significance of the Park for the Quality of Life in the City
18. The Large Parterre at Sanssouci
19. The Cherry Orchard at the New Chambers
20. The Sicilian and Nordic Gardens

- Train Station
- Restaurant
- Information / Visitor Center
- Museum Shop
- Taxis
- Ticket Sales
- Café / Snacks
- Entrance for Visitors with Mobility Impairments (with assistance)
- Barrier-Free Restrooms
- Restrooms
- Bus Parking Lot
- Car Park / Parking Lot
- Tram Stop
- Bus Stop
- Bicycle Route